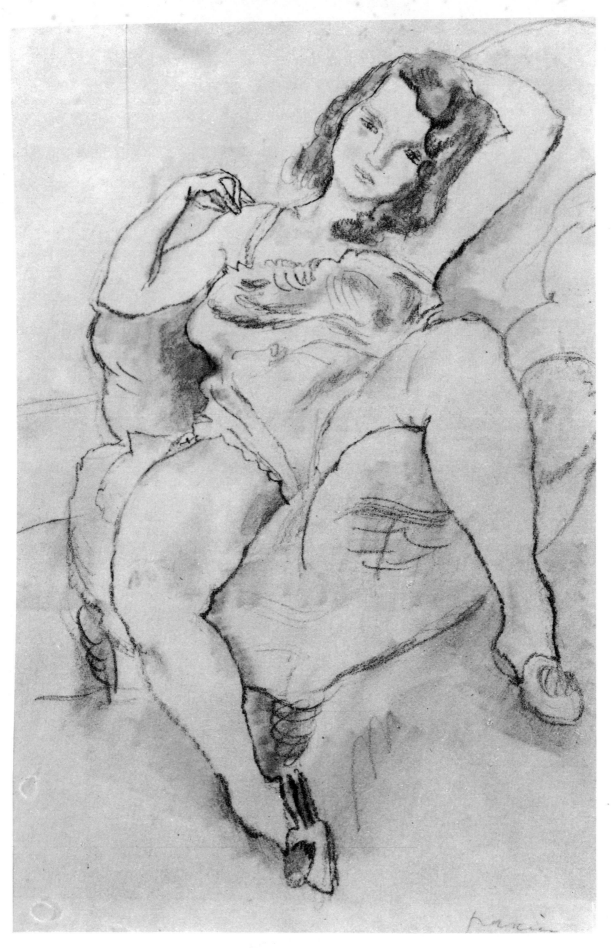

Girl in Slip; c. 1926

110 DRAWINGS

Selected, edited and introduced by

Alfred Werner

Dover Publications, Inc.

New York

Published in Canada by General Publishing Company,
Ltd., 30 Lesmill Road, Don Mills, Toronto, Ontario.
Published in the United Kingdom by Constable and
Company, Ltd., 10 Orange Street, London WC 2.

Pascin: 110 Drawings is a new work, first published by
Dover Publications, Inc., in 1972.
The editor and publisher are grateful to Klaus Perls for
his superb cooperation in supplying documentation, and to
Mr. Perls and Samuel Josefowitz for lending photographs
of drawings in their collections.

International Standard Book Number: 0-486-20299-2
Library of Congress Catalog Card Number: 71-154346

Manufactured in the United States of America
Dover Publications, Inc.
180 Varick Street
New York, N.Y. 10014

INTRODUCTION

"He stands out in this drab, preoccupied, modern world of ours with such startling brilliancy that at times it actually seems as though no one alive but he possesses real talent," Henry McBride wrote in the *New York Herald Tribune* in 1923, reviewing a Pascin show at a Manhattan gallery. "He is naughty. He's quite scandalous. But he is also very, very, very great. I take off my hat to Jules Pascin, for as a critic of art I have an immense respect for his priceless qualities of expression, at the same time that I wrap my cloak about me, in my stern character as a defender of the virtues, and peer about to see that no one watches as I gloat over the pictures."

Clearly McBride had his tongue in his cheek when he wrote of himself as "a defender of the virtues"; in the era of the flapper, the Charleston and the speakeasy, few sophisticated Americans would be shocked by the Bulgarian's unclassical nudes. Truly, in the United States (the artist became an American citizen in 1920) and especially in France, where he had his "home" (if that term can be properly applied to the untidy, cigarette-smoke-filled Boulevard de Clichy atelier of this restless wanderer), there was hardly any other living artist more readily admired by the cognoscenti than this magician, despite his rather anachronistic position within modern art: though he had friends among the Fauves, Cubists, Futurists, Expressionists and Surrealists, he did not allow himself to be more than mildly touched by any of the current schools and movements. Instead, he developed his own style, which fitted his personality and ideology, and which, if it reflected any influence at all, was closer in spirit to the French Rococo masters than to his contemporaries.

Pascin's death by suicide, at the age of forty-five, in the summer of 1930, was not precipitated by lack of artistic or financial success. On the contrary: he was on the eve of a one-man show in a highly prestigious Parisian gallery when he slashed his wrists and then hanged himself in his Montmartre studio. There were other reasons for this dramatic act of self-destruction: the tempestuousness of his relations with wife and mistress; ill health that required him to give up drinking; and finally the ennui of the man of integrity who felt that he had developed too facile a manner and was now woefully repeating himself (he was convinced that no artist should live more than forty-five years—if by then he had not already given his best, he would achieve nothing more after that age).

Pascin's genius was praised in the obituaries, and large memorial exhibitions were staged in Paris as well as New York. But by 1930 his reputation was already assailed, first in whispers, and then louder and

louder. In the grim Thirties, he—the agitated, pleasure-seeking but hard-to-please late "King of Bohemia," at ease everywhere and yet nowhere—was repudiated as an amoralist who had no interest in political or social values. On the other hand, in the ensuing age of Abstract Art, his work did not fare well because it was seemingly too "legible" for the new crop of artists who were trying to annihilate the last vestiges of the traditional concept of art as the imitation of nature. As an "eclectic," in love with the Old Masters he knew so well, as one who did not "experiment" and therefore had no influence on the "development" of modern art, Pascin was often left out of the literature on art.

In the early 1950's a *New York Times* reviewer described him as "one of the most underrated and forgotten talents of our time." His reputation did not make a real comeback until the 1960's, that is, until art lovers all over the world had begun to revolt against the tyranny of the non-objective, non-figurative style, and demanded art that once again responded to the phenomena of life with recognizable images. Along with other neglected figure-artists, Pascin was swept onto Madison Avenue and into American museums, five of which displayed a large traveling show of his works in all media in 1966 and 1967. There were also comprehensive Pascin shows in Paris, Munich and Vienna. The rise in appreciation of his work made itself apparent not only in favorable reviews which compared him to Fragonard for delicacy, verve, freshness and control, but also in the steeply mounting prices—up to $40,000—paid for his work.

Significantly, though, even during the years when Pascin was being pushed into the background in favor of men with a more "wholesome" philosophy or a more "advanced" aesthetic, nobody denied the extraordinary quality of his draughtsmanship (this praise often being coupled with a denigration of his capabilities as a painter). Reviewing a memorial show of the 1930's, the Paris correspondent of the *New York Times* argued that Pascin's genius lay only in draughtsmanship: "But the Parisian clientele does not consider pen drawings and watercolors very serious investments, and it is very regrettable indeed that Pascin, the Utamaro, the Constantin Guys of the 20th century, was discovered by the Paris dealers, who induced him to paint on canvas so that he might be launched on the big market."

Whether one agrees or not that his paintings are in the last analysis colored drawings, the comparison with the two master draughtsmen of earlier days need not be challenged. As a matter of record, Pascin—satirist, caricaturist and cartoonist—has also been called the equal of Hogarth, Goya, Rowlandson, Rops, Toulouse-Lautrec and Beardsley, all of whom were able to conjure a cosmos of expressiveness out of a single curve, a simple straight line. Pascin was not suited temperamentally for any laborious technique requiring days and even weeks of concentrated and disciplined attention. He did not like to spend more than one afternoon on a painting. The medium that served him best as a painter, he found, was oil paint much diluted with turpentine, since it permitted swift execution and allowed him to impress his visual excitement immediately on the

canvas. By the same token, as a print-maker he preferred the most direct method of engraving, drypoint, in which a sharp needle is used like a pencil to scratch the design onto the bare copper plate. But the media he used most often were those of the draughtsman par excellence—pencil and pen, chalk and pastel. At times he would draw on the same sheet with three or more different media, employing even such unorthodox ones as, for instance, burnt matches.

Julius Mordecai Pincas (1885–1930), who was to achieve fame under the anagram "pascin" (he used that signature—with a small p—for the first time, it seems, early in 1905),* was among the small élite whose talents are manifested very early. Employed as a clerk in the paternal grain business in Bucharest, the adolescent Julius, to his father's chagrin, wasted his office hours caricaturing customers in the firm's ledgers. Obviously he was no more interested in a commercial career than the young Sephardic Jew Camille Pissarro had been when clerking in the family's general store on St. Thomas in the Virgin Islands, while dreaming of a free life completely devoted to art.

Unfortunately, neither Pissarro's earliest works nor Pascin's have been preserved. Unlike Adèle de Toulouse-Lautrec, who was aware of young Henri's genius and kept every one of his juvenilia, neither Rachel Pissarro nor Sophie Pincas seems to have had the slightest inkling of her son's unusual gifts. But in the case of Pascin, we can trace his development at least from the time he was eighteen. An amusing drawing with water-color of a couple on a sofa lovingly watching their tiny grandson at play is reproduced in the present collection. It reveals a striking gift of observation and an amazing economy of line. The Israel Museum in Jerusalem owns several drawings that may even predate this one and are obviously the work of an extraordinarily gifted student.

In the art schools Pascin attended, first in Vienna and then in Munich, he was taught to see "correctly" and to make anatomically accurate renderings of the human body conscientiously, using careful contours with cross-hatched lines for modeling. But he gradually managed to shed all stiffness and stodginess, to concentrate on gesture, stance and posture, extracting the maximum of expressive character by means of swift suggestion rather than elaborate description.

The cartoons he contributed to the satirical anti-establishment Munich weekly *Der Simplicissimus*—the first appeared on March 14, 1905, when the artist was not quite twenty—are records of a development toward greater and greater freedom. The earliest, composed of too many loose and scratchy scribbles, and burdened by too much preoccupation with extraneous detail, are not "typical" Pascins. The wiry, bold line of a true Pascin did not come into being until about 1915, but these precocious cartoons and other drawings reveal a devastating power of observation. The amazingly sure line is light and playful. The smirking faces of the

* He never added his first name, even in its French form. His suicide note is signed "Jules Pincas dit Pascin."

impudent little prostitutes, whom he evokes with fascination, indicate the young artist's startling familiarity with the demi-monde of cheap cafés and brothels. But he neither condemns nor condones, though one might say he was more understanding than disgusted. While other *Simplicissimus* cartoons attack the bureaucracy, the military caste and the exploiters of workers, Pascin's are statements of everyday factuality, direct but impartial. He was not of the stuff of which "protest artists" are made. He was filled with neither bitterness nor sentimentality. In an idiom strongly influenced by Jugendstil (the German equivalent of Art Nouveau, named for another Munich avant-garde periodical, *Jugend*, to which Pascin did not contribute) he made very graceful, very witty drawings, strongly linear and decorative, usually superior to the other cartoons published. According to the diaries of young Paul Klee, whose offerings were rejected as unsuitable by the *Simplicissimus* editors, these gentlemen were not too happy about Pascin's very personal, sophisticated manner either. His work for *Simplicissimus* was interrupted by World War I; altogether, in the two periods 1905–1913 and 1920–1929, no more than some eighty-odd Pascin drawings were published in that periodical.

In Paris, where the young man arrived on Christmas Day, 1905, his mode of drawing became increasingly lighter, more informal, less exact, given to under- rather than overstatement (sometimes Pascin could have made a more complete statement, but by doing so would have sacrificed the quality of his work). The pen-and-ink drawings commissioned by Berlin's Paul Cassirer for a special edition of Heinrich Heine's *Aus den Memoiren des Herrn von Schnabelewopski*, though produced in Paris, are still close to Jugendstil, the only modern style to make a definite impact on the artist, notwithstanding occasional brief flirtations with other current Isms. But his manner had changed somewhat, had become more linear, without modeling, without shading. To be sure, with his rippling calligraphy and unorthodox outlook on life, Pascin was the ideal illustrator for the naughty and irreverent narrative by Heine, whose delight in strange women and picaresque adventures the artist fully shared (the *Memoiren* is the German poet's pseudo-autobiographical account of an aristocratic young rake who boasts of his sexual adventures, not only with prostitutes but also with so-called respectable ladies).

Curiously, it was in the country rather than in the big city that Pascin found his own style of drawing—even though he had been born in a city (Bulgaria's Danube port of Vidin) and raised in Bucharest, and his way stations had been Budapest, Vienna, Munich and Berlin, ending with his "domicile" in Paris. A summer at Ostend, the Belgian North Sea resort, in 1912, provided him with all the impetus he needed to create drawings and watercolors of beach scenes with a fluency and "abstractness" he had never accomplished before. These drawings later appeared in book form as *Ein Sommer* (Berlin, 1920).

But he did not become "pascin" until an ocean separated him for several years from his haunts in Europe. Some of his finest drawings are

among those he created in the New World. He arrived in New York in September 1914, having escaped from the obligation to serve as a soldier to the king of Bulgaria, whose subject he still was. The American artists who knew of him were those who had participated a year earlier in the gigantic International Exhibition of Modern Art, popularly known as the Armory Show. Pascin had been represented there by twelve works, ten drawings and watercolors and two engravings; of the six items then purchased by that discriminating collector, John Quinn, one drawing, *In the Park*, is now in New York's Museum of Modern Art.

Pascin had been in America only a few months when a gallery on Madison Avenue gave him his first one-man show of selected drawings. In the catalogue he was enthusiastically introduced to the public by the gallery owner, Martin Birnbaum, as "the most distinguished" of the young artists who had gathered at the Café du Dôme in Paris. Knowing that in the still puritanical America he might find it rather difficult to sell works of art so unorthodox in subject matter as well as technique, Birnbaum was almost apologetic in his text:

> Pascin's work offers the worst kind of stumbling block to the layman, for he chooses types which, while familiar, are never mentioned in polite society. The wings of the blasé cupids are stained with mud of the gutter, and his insolent chauffeurs, monstrous women, deformed criminals, emaciated, vicious children, uncanny animals, and careless inmates of the harem, call to mind Otto Weininger's unpleasant theories [a reference to the Viennese philosopher's controversial *Sex and Character*], and encourage the very pernicious habit of raising moral issues which theoretically have nothing to do with an honest attempt to analyze the artistic values of a painting or a piece of sculpture. If Degas is permitted unrelenting exercise to go behind the stage curtain, and search among scrubwomen for his inspiration, Pascin's subject matter is his own affair, and it may be argued that we ought to feel grateful to him for discovering so much beauty in ugliness.

Despite this ardent plea, sales were scant, the public refusing to be "grateful" to this foreigner for an art that could not possibly be hung in a respectable home. Though in poor financial circumstances, Pascin was able to enjoy all he saw in New York. Yet the metropolis did not exert much influence on his artistic output. A quick sketch of East Side mothers with their children, one of immigrants aboard a ship, one of bathers lunching on the sands of Coney Island, and three or four other pieces, were just about all he turned out. He did not linger on in the big city, but escaped from its icy winters to the pleasant climate of North Carolina, Louisiana, Texas, Florida, and even Cuba. There he relished not only the sunshine but also the slow pace of the South, so utterly different from the harshness and near-vulgarity of the unromantic, hard-working North. He went to places where a large part of the population was black, and immediately felt attracted to them.

Mr. Birnbaum knew of Pascin's itinerary, for as early as January 1915, in the above-mentioned catalogue, he referred to the artist's peregrinations:

> We are awaiting with impatience the first fruits of his sojourn in the Southern States and among the Negroes of the West Indies. Already he is . . . discovering for himself the peculiar beauties of various types of ebon-hued Americans. The delicious humor which crops out with almost every stroke of his pen will undoubtedly find rare material here.

The dealer's prophecy was fulfilled. Free of any racial prejudice, Pascin enjoyed himself wherever he went, no less on a steamboat going down the Mississippi than in a red-light district of the Deep South. He listened intently to the music of the Negroes, to their spirituals and blues, to the jazz—with its banjos, drums, castanets and guitars—that had not yet found its way to the more respectable places of entertainment in the North. It was the people rather than the architecture, or even the luxuriant vegetation, that fascinated him. In the resulting drawings and watercolors, the Southern cities, especially Charleston and New Orleans, are, of course, identifiable: the narrow streets, the old houses with overhanging balconies, the large palm trees behind the primitive shacks, the undulating hills and the rich blossoms. Yet invariably they serve as mere backgrounds: attention is focused on the half-naked men toiling under the blazing sun; on fruit peddlers with mule and rickety wagon dispensing their wares; on overseers mounted on slender horses, men engaged in excited disputes or relaxing in cafés; on picnics in parks—a *comédie humaine* in which sharp realism is tempered with a leaven of disarming humor.

The products of these trips were pencil, crayon or pen-and-ink sketches. Often watercolor is superimposed on the drawing; flexible and convenient, this medium permits chromatic notations and the capture of moods that could never be recorded by the slow methods of painting. Some of these little pictures were collected into sketchbooks. One was acquired by the Museum of Modern Art, New York, another by the Marion Koogler McNay Art Institute of San Antonio, Texas. In 1966, the latter sketchbook was reproduced in offset and published for the Institute by the University of Texas Press. In his introduction, the Institute's director, John Palmer Leeper, wrote:

> He saw everything: the fishing boats and sailboats at anchor in quiet waters, the graceful, dignified natives at their leisurely work, gathered in lively groups, or simply sitting in the shade watching the movement of a village street. The quality of heat, indolence, silence pervades every drawing.

The months Pascin spent traveling in the Western Hemisphere were less turbulent than the years that lay ahead—years of agitation and of uninterrupted success in the whirlpool of Paris. In the Americas, Pascin

often lacked money, but he was still untouched by the frenzy that eventually was to devour and kill him. Leeper expressed thankfulness that Pascin's life "knew an untroubled interlude, that the artist found his hot, quiet country with its pleasant, gay, and not gloomy people."

These drawings were highly appreciated by colleagues when they were seen in Mr. Birnbaum's gallery (oddly named the Berlin Photographic Company), and also in a group show at New York's Macbeth Gallery. There were not many sales. Pascin's special gift for swift, yet precise statement, the freshness of his out-of-doors sketches that radiated so much charm in such small format, required a more alert kind of customer, appreciative of a genius who could transfer his vision to paper with the speed of a camera lens—an artist with built-in wisdom, capable of elimination, elision and constructive distortion. These delicate things were still caviar to the general.

George Grosz remembered Pascin sitting in a Paris café and drawing "elegant little obscenities with uncanny skill" on the margins of newspapers. Like Toulouse-Lautrec, who had died prematurely four years before Pascin's arrival in Paris, the Bulgarian was never idle. These two men, born about two decades apart, had much in common, especially a thirst for life that sought to capture all its phenomena in quick sketches of incredible spontaneity. Both often observed life from unusual places and angles; both were infatuated with woman in all of her guises. For both, drawing was a catharsis, the major outlet for the obsessions which consumed them. What they set down in a few lively strokes caught gesture and character so splendidly that the drawing gives the impression of completeness even when the line is thinned to the vanishing point.

Paris, where Pascin had his "residence" in the decade prior to the World War, and where he "settled" again in 1920 after his self-imposed exile to America, was the scene of his final years and became his Fate. From his many trips in Europe and North Africa, during which he did numerous watercolors and drawings, he would return to the cafés, restaurants and bordellos of Paris, to his quarrels with wife and mistress, and to the loathed production of potboilers—for he was unacquainted with thriftiness and was always in need of money to treat his friends and countless hangers-on lavishly. So much has been written about the "hedonist" Pascin and about his transformation into a pale chain-smoker and alcoholic suffering from cirrhosis of the liver (and, perhaps, even more from the chagrin of turning out the same types of pictures rapidly and repeatedly, surrendering his artistic freedom to satisfy his dealers), that there is nothing to add to the unsavory "myth."

There were, of course, those who saw only the outside, the lascivious Bohemian who wrecked his body through dissipation. Others, however, were astute enough to note his one unfailing characteristic: "He was always drawing," Pascin's friend Henri Bing recalled, "drawing when on his feet, when lying down, when sitting; drawing everything on every material. Paper covers on the pub table, menu-cards, cigarette

cartons, every surface attracted his pencil, pen, or brush. He would seize any medium at his disposal—ink that he might thin out with soda water, the burnt ends of matchsticks, dregs of coffee—to make, with uncanny skill, sketches of companions or passers-by."

When circumstances restrained Pascin from drawing openly, he made notations on a little pad concealed in his pocket. As a kind of game, he would draw on sheets of carbon paper laid on top of the drawing paper (the "transfer" drawings). Often, as he was sketching the fleeting world around him, a drawing would fall to the ground and he would not bother to pick it up; many a stranger retrieved a piece that might command hundreds of dollars in today's art market. An unknown number of drawings were undoubtedly filched by the visitors to his littered studio, where heaps of sketches were to be found everywhere; but he might beg friends or strangers, about to help themselves to his drawings, "Don't take them from this pile, I need them, take them from another."

Moreover, many sketches by this indefatigable man who, in the words of his friend, the British artist Horace Brodsky, "drew as he breathed—without effort," must have been lost forever through careless-ness, and others may be still floating around unidentified (many of his drawings bear no signature; others have a forged signature, and there are, of course, quite a few faked "Pascins"). Some drawings, whether signed or unsigned, carry the official stamp, "Succession Pascin, Le Commission-naire Priseur," or merely "Atelier Pascin"; these groups of drawings were inventoried in the artist's studio right after his death.

While Pascin's paintings are largely works of the twenties, he drew feverishly throughout his career. His drawings are those of a man whose eyes always looked inquisitively—in fact, greedily—at the world around him, and who drew because only the swiftest means could capture his impulse. His finest drawings are perhaps those made between 1915 and 1925. In his last years his productivity as a draughtsman decreased some-what, as he worked more and more with oils. The drawings of that period lack some of the finality of his earlier ones; their impatience is more clearly felt, indicating that the artist's feverish productivity had found another outlet.

Among his drawings, there are the quick portraits of persons close to him, especially his wife Hermine David (herself a remarkable artist) and his paramour Lucy Krogh; and such friends as the American illustrator George Overbury ("Pop") Hart, with whom Pascin roamed the Vieux Carré of New Orleans, the dealer Justin K. Thannhauser and the painter Rudolf Levy. The self-portraits are not numerous. There are many sketches of anonymous people in cafés and night clubs; preliminary drawings for the books Pascin was to illustrate; drawings, in a rather irreverent manner, of biblical or mythological scenes; and, of course, many devoted to the subject closest to him, woman, whose "entomologist" he was to become.

Like Degas and Toulouse-Lautrec, Pascin was fascinated by the

female as a sexual animal far less inhibited in attitude and gesture than the male. But he characterized woman less cruelly than those artists did. He drew her a hundred, a thousand times, seated or reclining, nude or partly clad—more often than not choosing the least chaste position, with her clothes, if she wore any, in highly provocative disorder. His Parisienne was usually still pubescent, though already bored and blasé. Occasionally he would also draw huge, fat middle-aged women. He projected the girl's ennui, her mindless somnolence and the pathos of her spoiled youth with an exquisitely tentative line, and not infrequently with added washes of a sensitively iridescent color. Through the delicacy of his workmanship, in such astonishing contrast to the squalid disorder of his models' lives, he redeemed by his artistic integrity what might otherwise have been just monotonously erotic. At times, the rhythmic flow of lines knitted together two or three reclining figures with a daring foreshortening of form.

Pascin often searched for the unconventional angle. The viewer is permitted to "stand over" a girl or "sit on the floor" very close to a girl with her legs casually parted. Wearing nothing or almost nothing, Pascin's women often display themselves very much as if they were sexually involved with the spectator. Other artists, such as Degas, maintain a very reserved distance.

Through his delicately nuanced, and often ironic, studies of women— many of them ordinary prostitutes, it seems—Pascin is related in a general way to Lautrec. But his sketches have a certain personal grace and tenderness that clearly belong to himself alone, and bespeak his sense of identification with these defeated creatures. The models are mostly young girls in sprawling poses, Lolita types *avant la lettre*. They have much in common with the girls depicted by certain eighteenth-century French painters (especially Boucher) and engravers. Pascin captured the graceful insolence of the *filles de joie*, showing how sensitive he was to the tragedy of ruined lives. A kind of mystical atmosphere envelops this flotsam and jetsam. With their short legs and vague expressions, alone or in pairs, they give the impression of an existence indifferent to time.

Today, Pascin's draughtsmanship—impulsive, unguarded, unpremeditated—is admired more than ever before. He is no longer omitted from textbooks on modern art. After all, he was the most typical representative of the Ecole de Paris—a misnomer, perhaps, and yet a term appropriate to a man like him, without ties, without roots, without a real homeland, cosmopolitan, sophisticated, civilized, and for whom Paris was all that mattered.

ALFRED WERNER

LIST OF ILLUSTRATIONS

The dimensions (where available) are given in inches, height before width.

Frontispiece

Girl in Slip; c. 1926; crayon. (Mrs. Philip F. Newman, Bala-Cynwyd, Pa.)

1. The Immigrants; 1902; watercolor; $18\frac{1}{8} \times 24\frac{1}{8}$. (Mrs. Herbert C. Morris, Philadelphia) [The signature is a rubber stamp added later.]

2. The Violet Sofa (Waiting); 1903; watercolor; $9\frac{7}{8} \times 8\frac{1}{8}$. (Miss Lenore Schneiderman, New York) [Signature not by the artist.]

3. Circus Scene; c. 1903; watercolor; $8 \times 7\frac{1}{8}$. (Miss Lenore Schneiderman, New York)

4. Family Scene; signed "pincas 03"; watercolor; $8\frac{1}{8} \times 10\frac{1}{4}$. (Perls Galleries, New York)

5. The Lower Depths; 1905; pen and ink; $7\frac{1}{8} \times 13\frac{3}{8}$. (Samuel Josefowitz, Lausanne)

6. Café Scene with Three Ladies; 1905; ink and wash. (Samuel Josefowitz, Lausanne)

7. The Three Girlfriends; 1905; pen and ink; $8\frac{1}{2} \times 9\frac{7}{8}$. (Samuel Josefowitz, Lausanne)

8. Three Prostitutes with a Monkey; 1905; ink and watercolor; $9\frac{7}{8} \times 10\frac{1}{2}$. (Samuel Josefowitz, Lausanne)

9. Ladies in a Café; 1905; ink and wash. (Samuel Josefowitz, Lausanne)

10. "The Spanish Lady" with Two Gentlemen; 1905; pen and ink; $6\frac{3}{8} \times 6\frac{5}{8}$. (Samuel Josefowitz, Lausanne)

11. Women, Child and Dog; c. 1905; watercolor; $7\frac{3}{4} \times 6\frac{1}{4}$. (Perls Galleries, New York)

12. Promenade at the Spa; c. 1905; pen and ink. (Samuel Josefowitz, Lausanne)

13. Crowded Room; c. 1905; ink and watercolor; $8\frac{3}{4} \times 10\frac{3}{4}$. (Owner unknown)

14. In the Park; c. 1905; ink, pencil and watercolor; $9\frac{1}{2} \times 9\frac{1}{2}$. (Detroit Institute of Arts)

15. Louis with Three Ladies; 1906; ink and wash; $10\frac{1}{4} \times 7\frac{7}{8}$. (Samuel Josefowitz, Lausanne)

16. Siesta in the Country; c. 1906; watercolor; $5\frac{5}{8} \times 8\frac{1}{2}$. (Peter Deitsch Gallery, New York)

17. The Country Girl; c. 1907; pen and ink; $9\frac{5}{8} \times 6\frac{7}{8}$. (Miss Lenore Schneiderman, New York)

18. Café in a Park; 1908; ink and watercolor; $5\frac{5}{8} \times 6\frac{3}{8}$. (Samuel Josefowitz, Lausanne)

19. The Pleasures of the Café; 1908; ink and wash; $5\frac{3}{4} \times 7\frac{7}{8}$. (Samuel Josefowitz, Lausanne)

20. Café Scene; 1908; pen and ink; $7\frac{7}{8} \times 12\frac{1}{4}$. (Perls Galleries, New York)

21. Scene from a Play; 1908; ink and watercolor; $8\frac{1}{2} \times 10\frac{7}{8}$. (Galerie Marcel Bernheim, Paris)

55. New Orleans Intermezzo; 1918; watercolor; $7\frac{3}{4}$ × 11. (Mrs. Philip Newman, Bala-Cynwyd, Pa.)

56. A Park in New Orleans; 1918; watercolor; $6\frac{3}{4}$ × $8\frac{3}{8}$. (Perls Galleries, New York)

57. In New Orleans; 1918; watercolor; 7 × $9\frac{1}{8}$. (Perls Galleries, New York)

58. Hermine David; 1918; ink and pastel; 11 × $8\frac{1}{2}$. (Private collection, New York)

59. Hermine David; 1918; crayon; 11 × $8\frac{3}{8}$. (Perls Galleries, New York)

60. Man Reading; 1918; watercolor; 9 × $7\frac{5}{8}$. (Perls Galleries, New York)

61. The Reception; c. 1918; carbon transfer drawing; $13\frac{1}{4}$ × $10\frac{3}{4}$. (Mrs. Peter F. Rousmaniere, Cambridge, Mass.)

62. Portrait of the Artist and His Friend; c. 1918; pen and ink; $19\frac{1}{2}$ × $19\frac{7}{8}$. (Jacques Sarlie, Paris)

63. Nude; c. 1918; ink and watercolor; c. 10 × 14. (Ferdinand Howald Collection, Columbus Gallery of Fine Arts, Columbus, Ohio)

64. On the Ferry; dated 1919, New York; watercolor; $8\frac{1}{4}$ × $10\frac{5}{8}$. (Perls Galleries, New York)

65. Two Prostitutes on a Sofa; 1919; watercolor; $8\frac{7}{8}$ × 14. (Moses Soyer, New York)

66. Harbor Scene; 1919; pencil; $9\frac{7}{8}$ × $7\frac{7}{8}$. (Perls Galleries, New York)

67. Hermine David in the Tropics; 1919; watercolor; $14\frac{1}{8}$ × $10\frac{3}{8}$. (Perls Galleries, New York)

68. Hermine on Her Bed; c. 1920; ink and wash; $7\frac{3}{4}$ × 11. (Private collection, New York)

69. Nude Leaning Backward; 1920; pen and ink; $12\frac{1}{2}$ × 19. (Andrew Crispo, New York)

70. In the Subway; 1920; pen and ink; 7 × 10. (Perls Galleries, New York)

71. Ancient History: Socrates and His Disciples Reviled by the Courtesans; 1920; ink and watercolor; $12\frac{3}{8}$ × $18\frac{7}{8}$. (Perls Galleries, New York)

72. Landscape in Tunis; 1921; carbon transfer drawing; 8 × $9\frac{3}{4}$. (Perls Galleries, New York)

73. An Artist's Studio; 1921; ink and watercolor; $8\frac{1}{2}$ × 10. (N.Y. Psychoanalytic Institute, New York)

74. "The Lights of Paris"; 1921; watercolor; $5\frac{7}{8}$ × $7\frac{3}{8}$. (Mr. and Mrs. Milton S. Cohn, Roslyn, N.Y.)

75. Three Prostitutes; c. 1921; watercolor; $7\frac{3}{4}$ × $11\frac{3}{4}$. (Private collection, New York)

76. Nude; 1922; pencil; $9\frac{5}{8}$ × 12. (Perls Galleries, New York)

77. Drawing Lesson; 1922; pencil; $9\frac{1}{2}$ × $12\frac{1}{2}$. (Perls Galleries, New York)

78. Woman Reading; 1923 (New York); ink and pencil; $21\frac{1}{4}$ × 17. (Samuel Josefowitz, Lausanne)

79. Fanny and Emil Ganso; c. 1923; pen and ink. (Robert Elkon Gallery, New York)

80. In the Café; 1925; crayon; $7\frac{5}{8}$ × $9\frac{1}{2}$. (Perls Galleries, New York)

81. Resting on a Chaise Longue; 1925; crayon and sanguine; 10 × $13\frac{1}{2}$. (Mr. and Mrs. Bernard Kleinman, Scarsdale, N.Y.)

82. Homage to Berthe Weill; 1925; watercolor; 18 × $23\frac{1}{4}$. (Perls Galleries, New York)

83. The Visitors; c. 1925; carbon transfer drawing; $9\frac{1}{2}$ × $13\frac{1}{4}$. (Allan Frumkin Gallery, New York)

84. Rear View of Kneeling Nude; c. 1925; crayon; $16\frac{7}{8}$ × $12\frac{1}{4}$. (Charles K. Feldman, New York)

85. Resting on a Sofa; c. 1925; crayon; 8 × 14. (R. A. Ellison, Jr., Fort Worth, Texas)

86. The Girl Friends; 1925; pen and ink; 14¾ × 11⅝. (Mrs. James Fentress, Villanova, Pa.)

87. Rear View of Standing Seminude Woman; 1926; pencil; 19 × 11¾. (Carter Burden, New York)

88. Mr. and Mrs. Georges Eisenmann; 1926; ink and wash; 18¼ × 24⅝. (Perls Galleries, New York)

89. Georges Eisenmann; dated May 11, 1926; pastel; 19¼ × 25. (Perls Galleries, New York)

90. Redhead in a Blue Slip; 1926; ink and watercolor; 12¼ × 9. (Samuel Josefowitz, Lausanne)

91. Girl in an Armchair; c. 1926; crayon. (Mrs. Philip F. Newman, Bala-Cynwyd, Pa.)

92. Reclining Girl; c. 1926; pencil; 11 × 17. (Fort Worth Art Association, Fort Worth, Texas)

93. Reclining Woman; c. 1926; pastel; 19 × 25½. (Evelyn and John Nef, Washington, D.C.)

94. Two Seated Young Girls; 1927; pencil; 19⅛ × 15. (Carter Burden, New York)

95. Nude in an Armchair; 1927; crayon; 18 × 13½. (H. Mantell, New York)

96. Girl in an Armchair; c. 1927; colored crayons; 24 × 19. (Vladimir Horowitz, New York)

97. Nude in an Armchair; 1927; charcoal and pastel; 18½ × 11. (Samuel Josefowitz, Lausanne)

98. Nude with Hair Undone; c. 1927; pastel; 18⅛ × 22⅛. (Perls Galleries, New York)

99. Women with Children; 1928; carbon transfer drawing; 8⅜ × 9½. (Samuel Josefowitz, Lausanne)

100. Seated Girl; 1928; charcoal and wash; 19⅜ × 25¼. (Museum of Modern Art, New York)

101. Reclining Nude; 1928; charcoal; 19⅞ × 25½. (Museum of Modern Art, New York)

102. Model Resting; 1928; pencil; 21¼ × 16. (Perls Galleries, New York)

103. Girl in an Armchair; 1928; pencil; 16½ × 12½. (John Rewald, New York)

104. At the Cabaret; 1928; ink and transfer drawing; 18¾ × 22¾. (Samuel Josefowitz, Lausanne)

105. Bal Tabarin; c. 1928; drypoint; 11 5/16 × 13 5/16. (Museum of Modern Art, New York)

106. Boston Streetcar; c. 1928; watercolor. (Samuel Josefowitz, Lausanne)

107. The Two Girl Friends; 1929; pencil and pastel; 18 × 23¼. (Samuel Josefowitz, Lausanne)

108. Girl on Her Bed; 1929; crayon; 21¼ × 28⅛. (Andrew Crispo, New York)

109. Yvonne; 1929; pencil; 16¾ × 11⅛. (Perls Galleries, New York)

1. The Immigrants; 1902

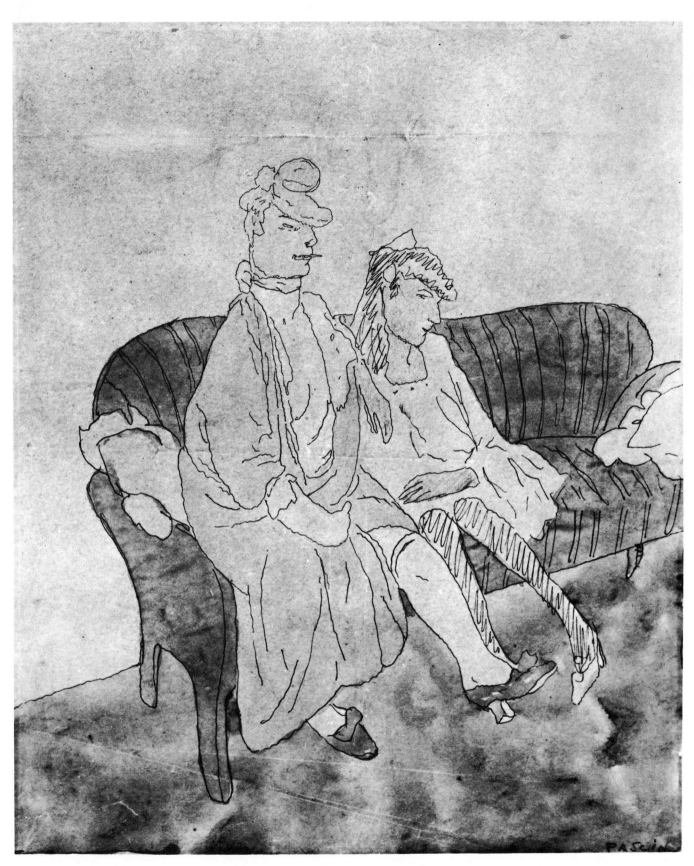

2. The Violet Sofa (Waiting); 1903

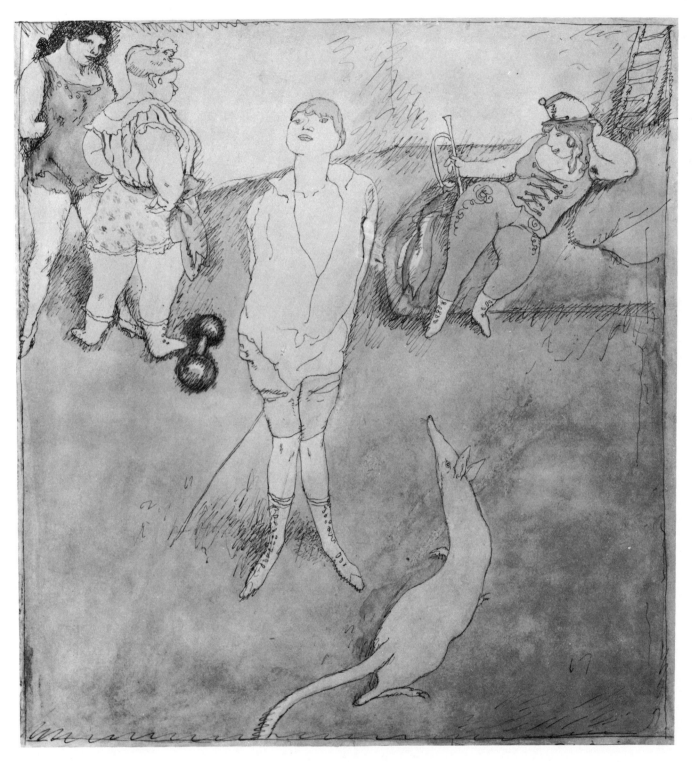

3. Circus Scene; 1903

4. Family Scene; 1903

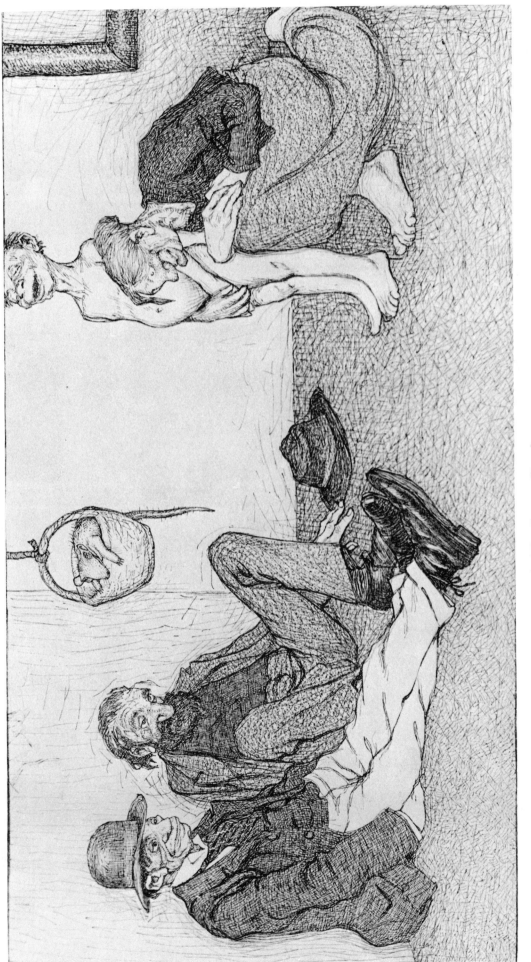

5. The Lower Depths; 1905

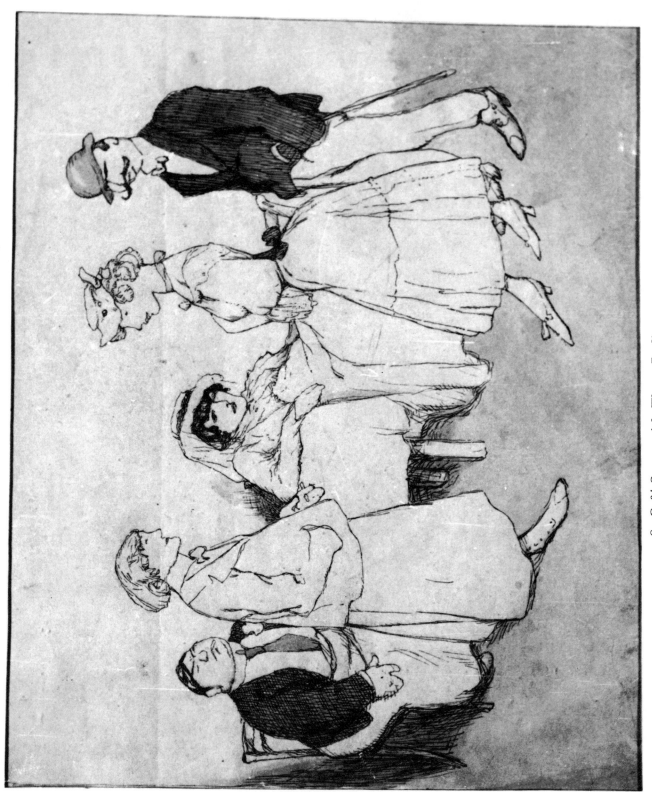

6. Café Scene with Three Ladies; 1905

7. The Three Girlfriends; 1905

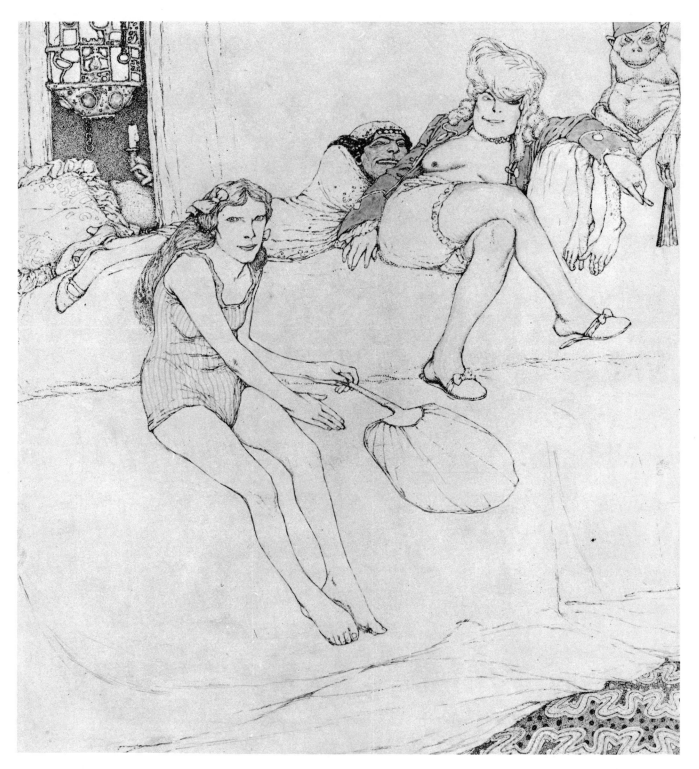

8. Three Prostitutes with a Monkey; 1905

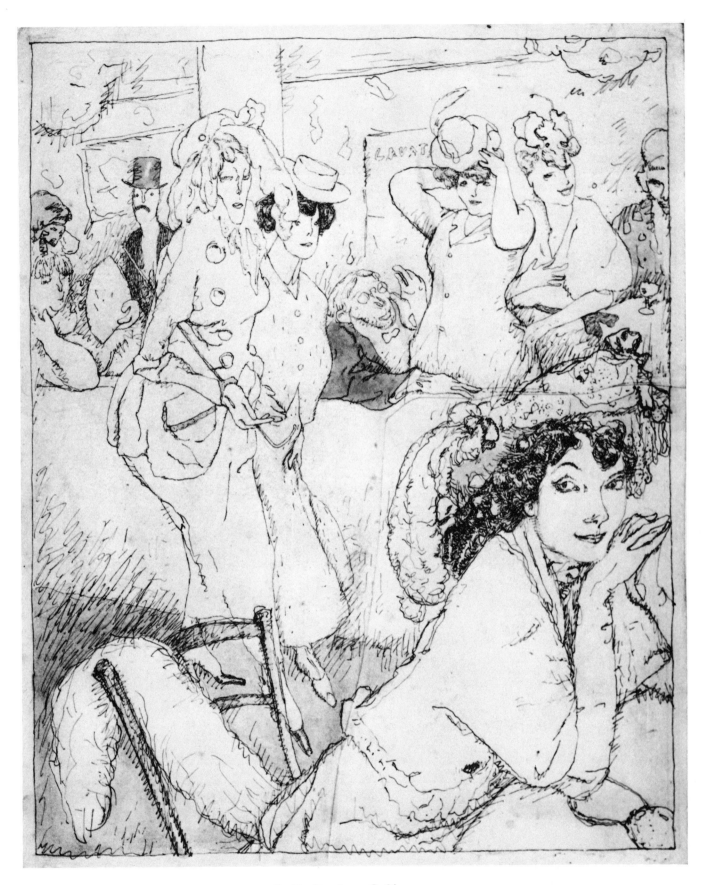

9. Ladies in a Café; 1905

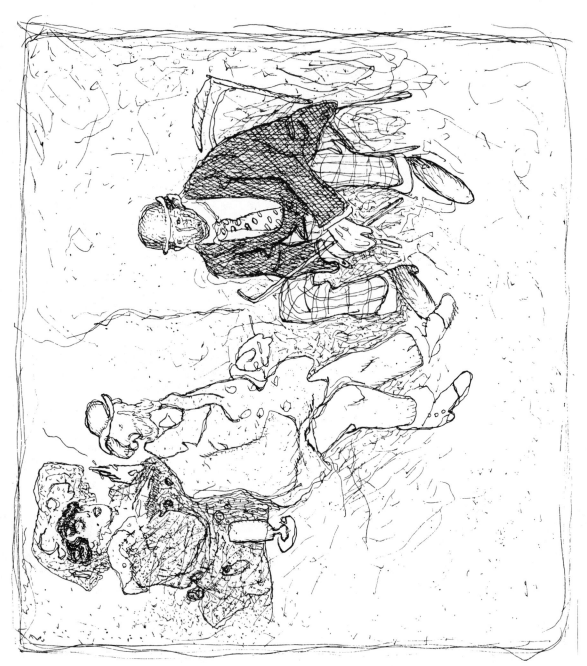

10. "The Spanish Lady" with Two Gentlemen; 1905

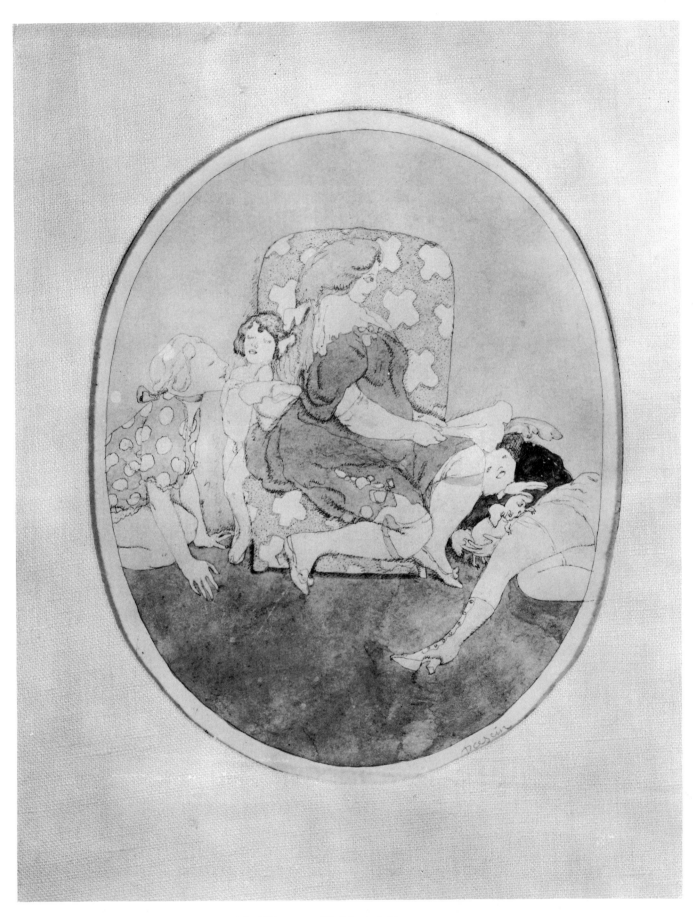

11. Women, Child and Dog; c. 1905

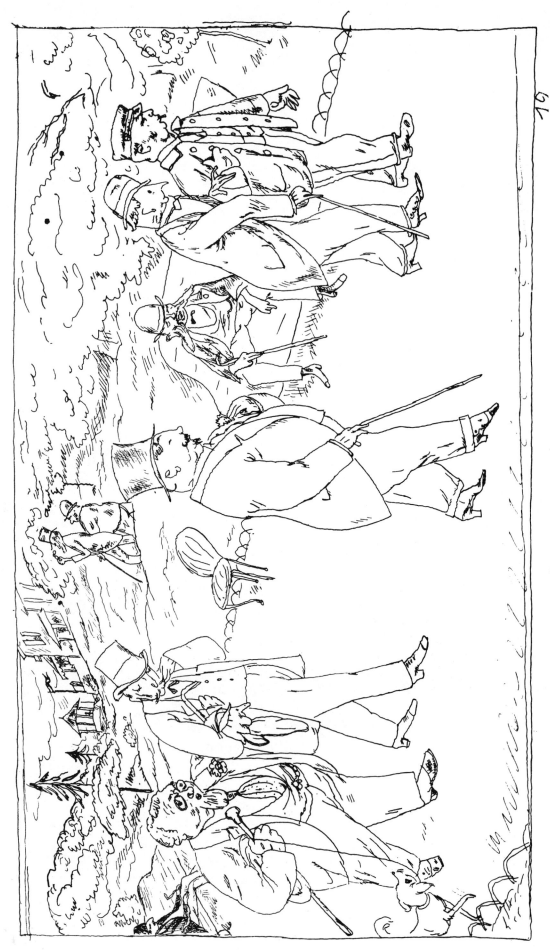

12. Promenade at the Spa ; c. 1905

13. Crowded Room; c. 1905

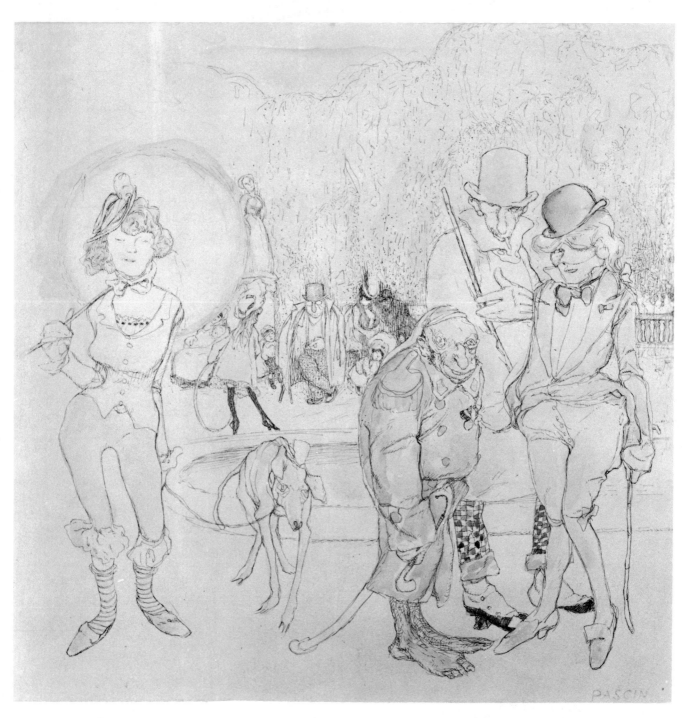

14. In the Park; c. 1905

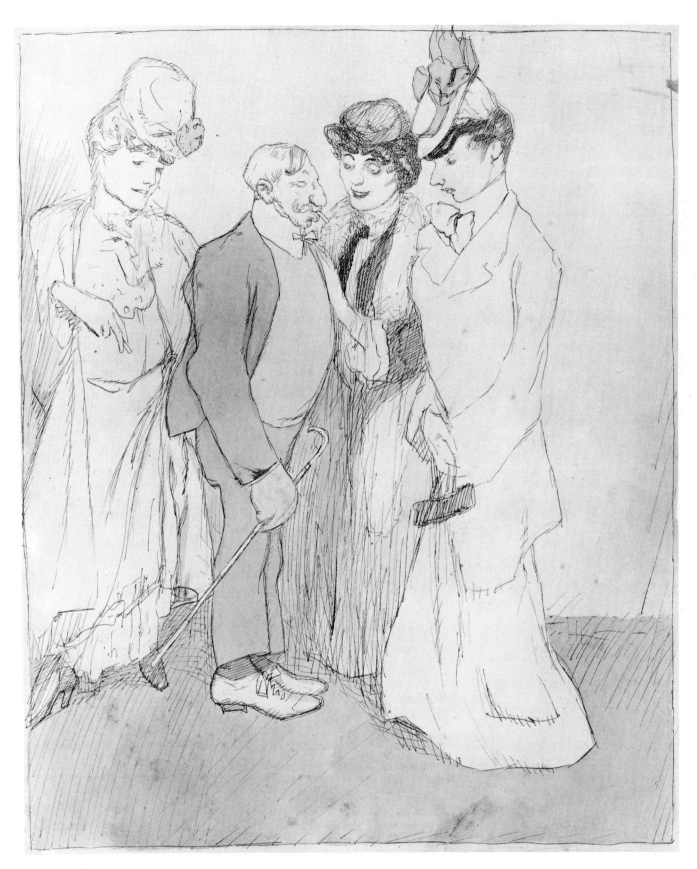

15. Louis with Three Ladies; 1906

16. Siesta in the Country; c. 1906

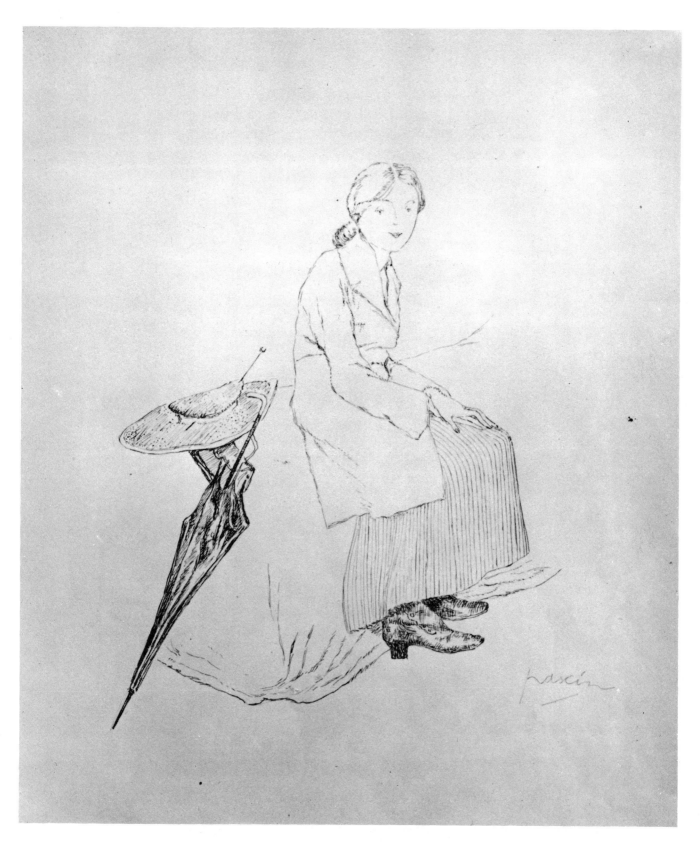

17. The Country Girl; c. 1907

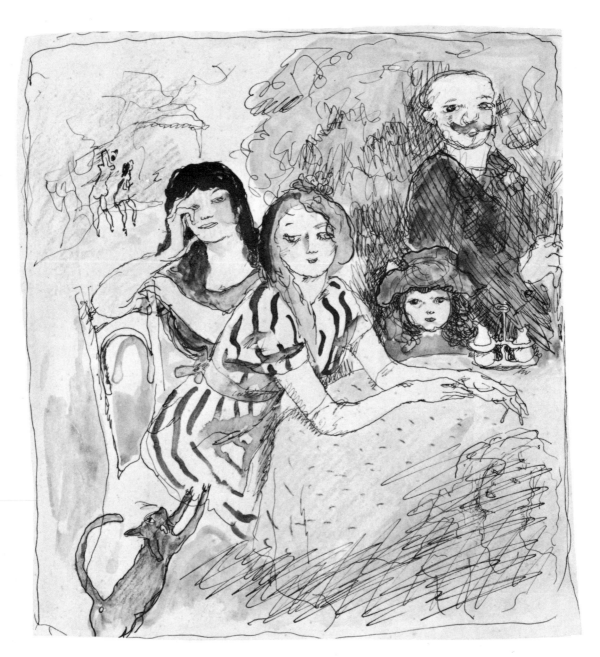

18. Café in a Park; 1908

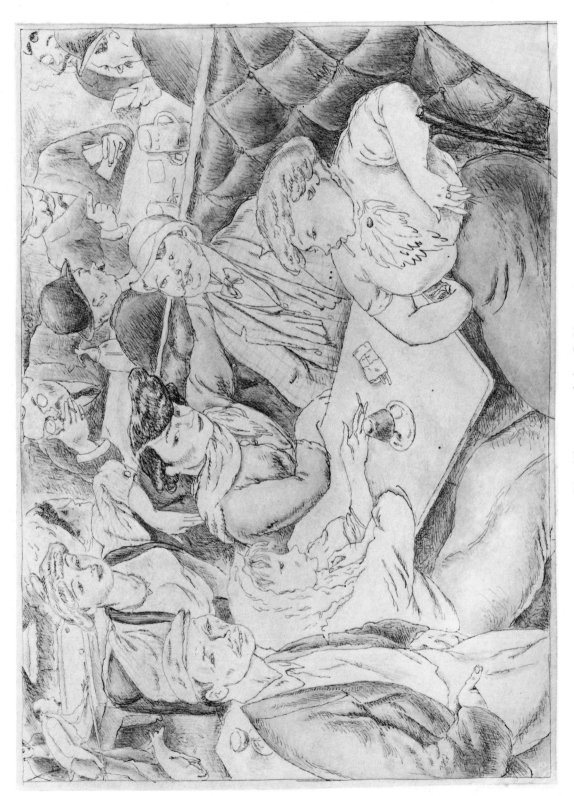

19. The Pleasures of the Café; 1908

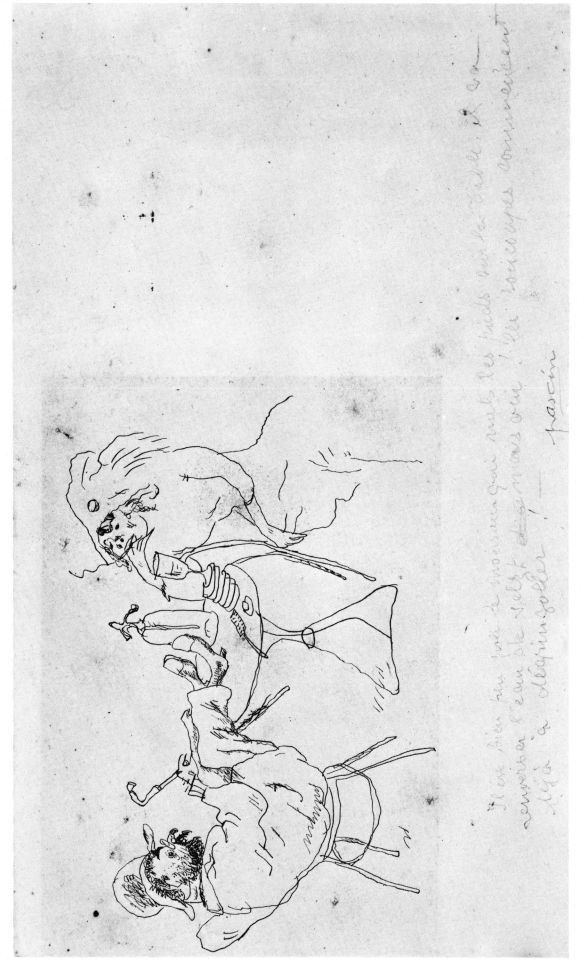

20. Café Scene; 1908

Inscription: "That man putting his feet on the table is not very polite. He is going to knock over the Seltzer water—definitely! The saucers are already beginning to tumble down!"

21. Scene from a Play; 1908

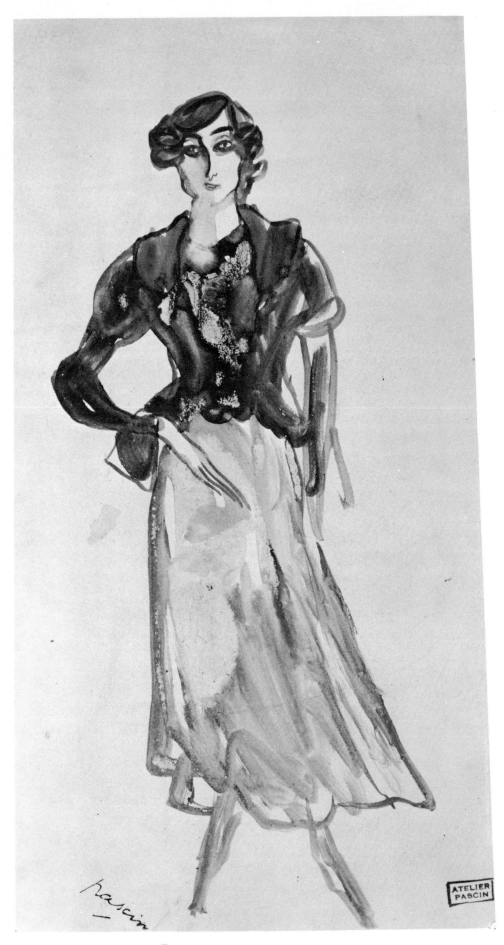

22. Portrait of a Standing Woman; 1909

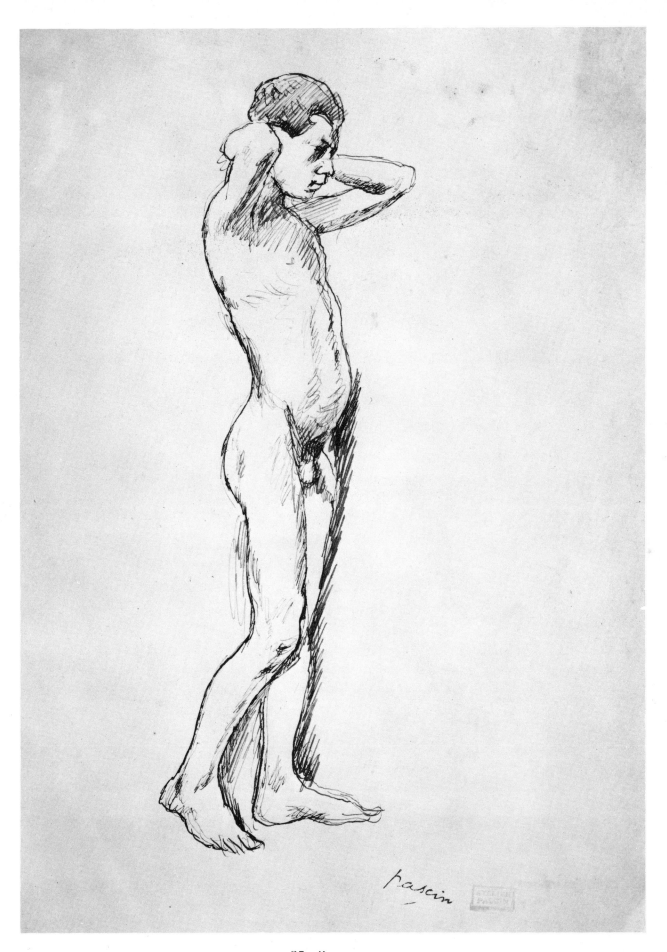

23. Boy; 1910

24. Picnic; 1910

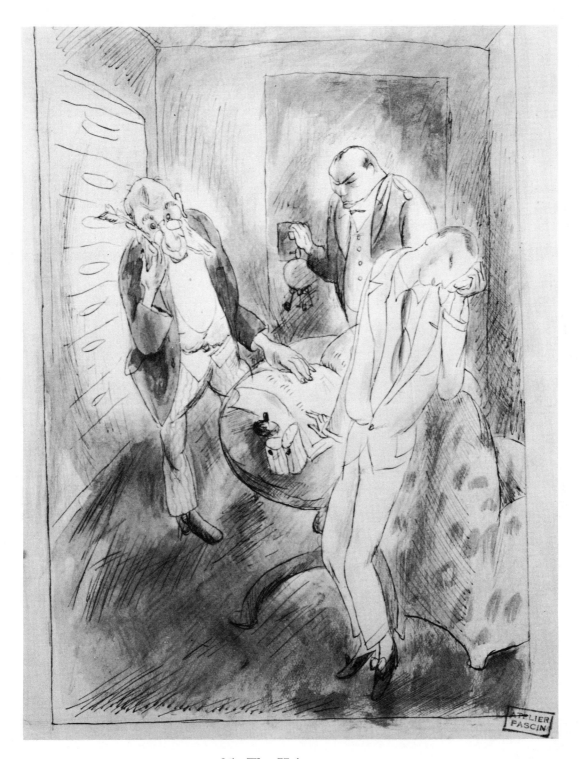

25. The Heir; c. 1910

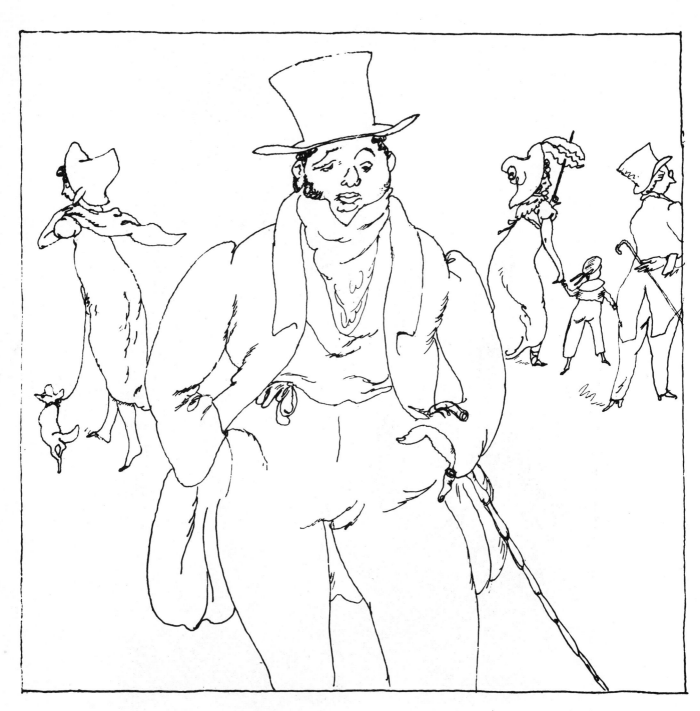

26. A Citizen of Hamburg Strolling on the Jungfernstieg (illustration for Heine's *Aus den Memoiren des Herrn von Schnabelewopski*); c. 1910

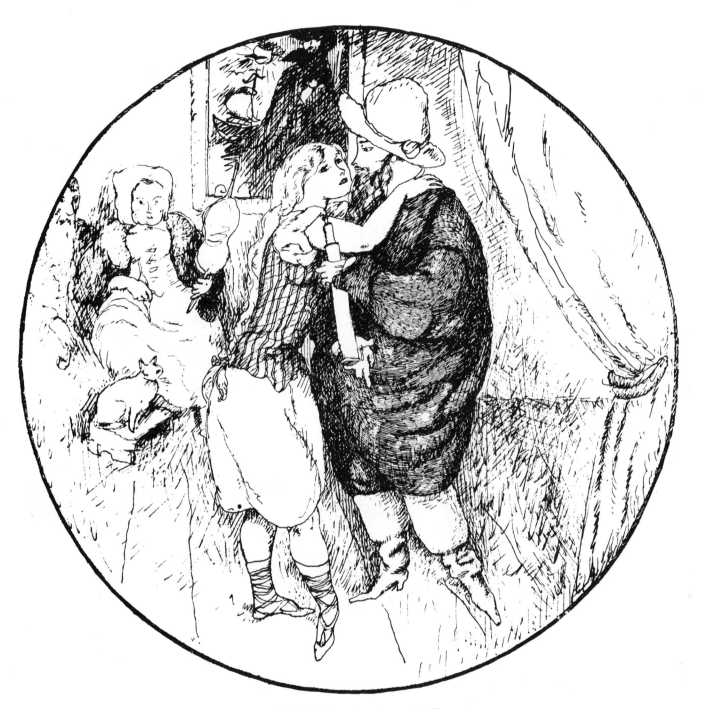

27. Katharina and the Flying Dutchman (illustration for Heine's
Schnabelewopski); c. 1910.

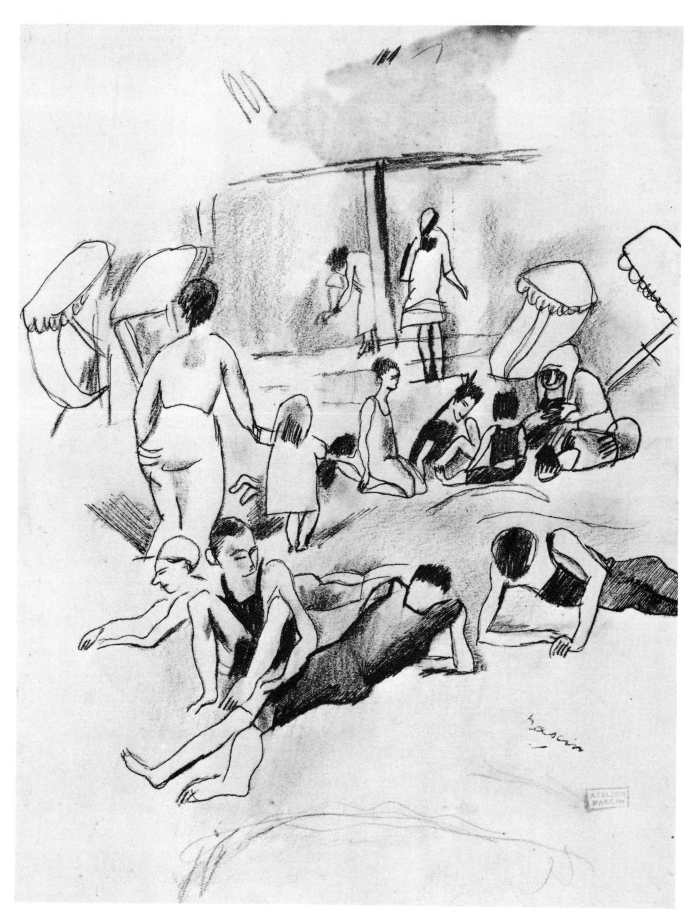

28. On the Beach, Dieppe; 1911

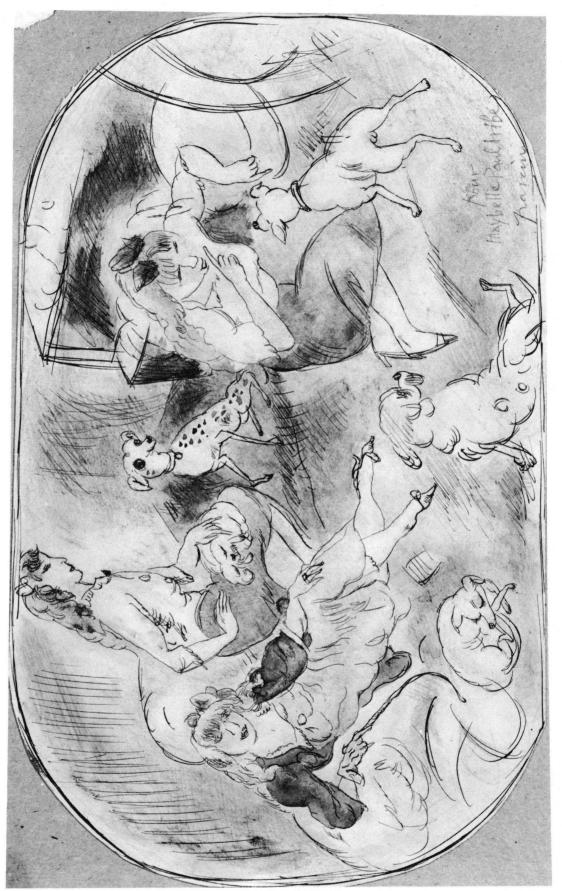

29. Girls and Dogs; 1912

30. Seated Girl; c. 1912

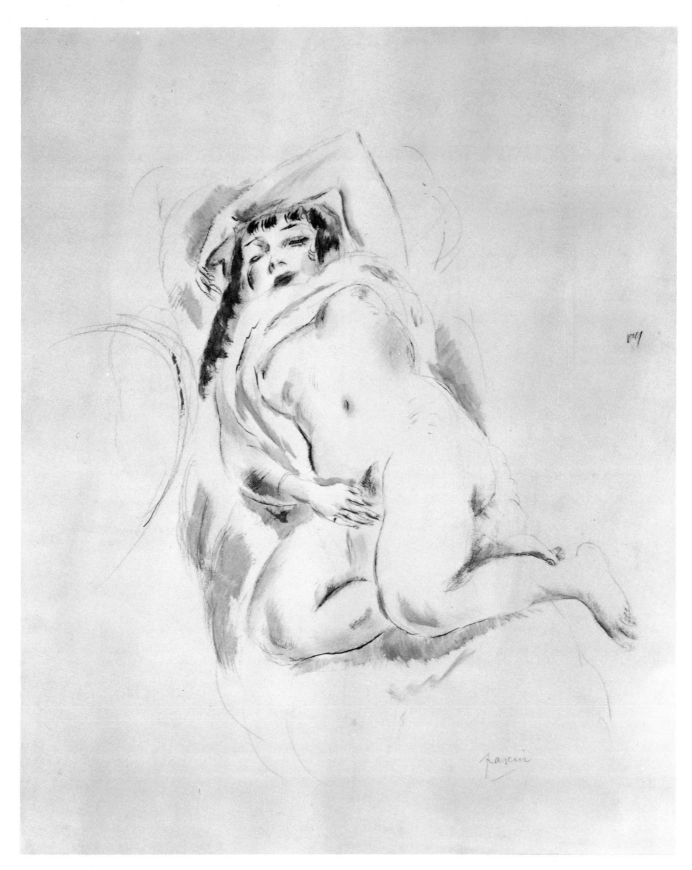

31. Reclining Woman; 1914

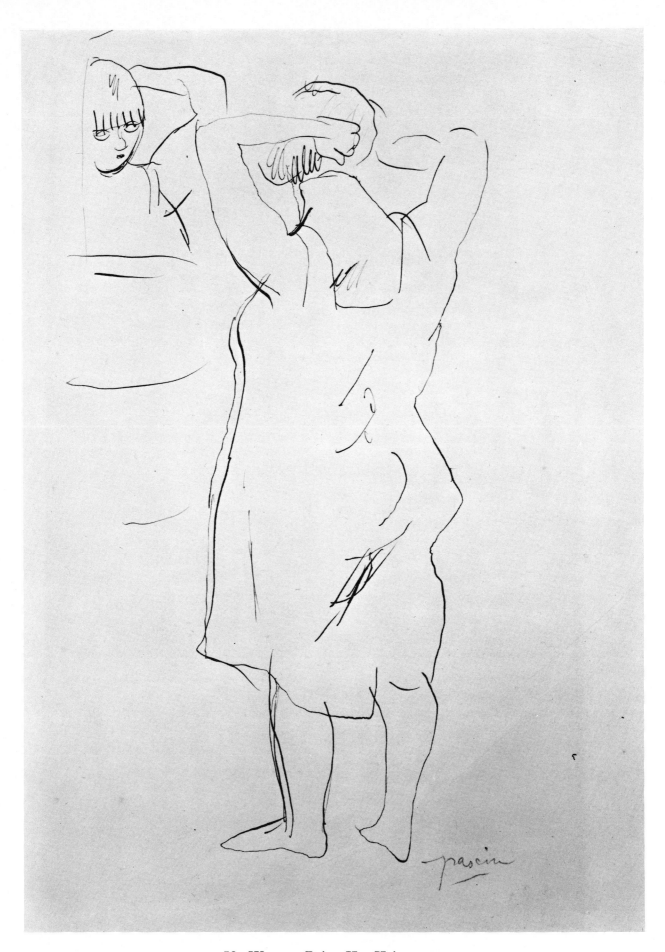

32. Woman Doing Her Hair; 1914

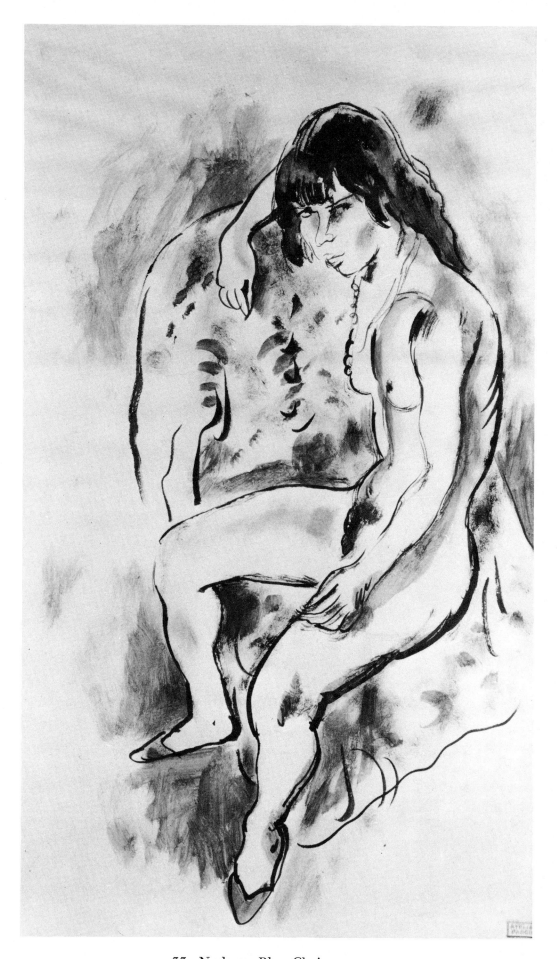

33. Nude on Blue Chair; c. 1915

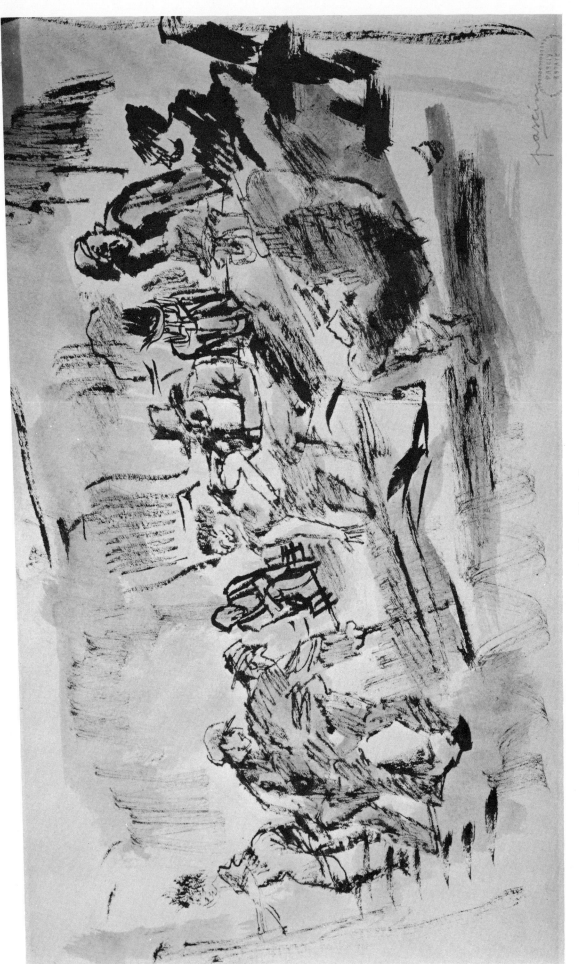

34. New York Scene; 1915

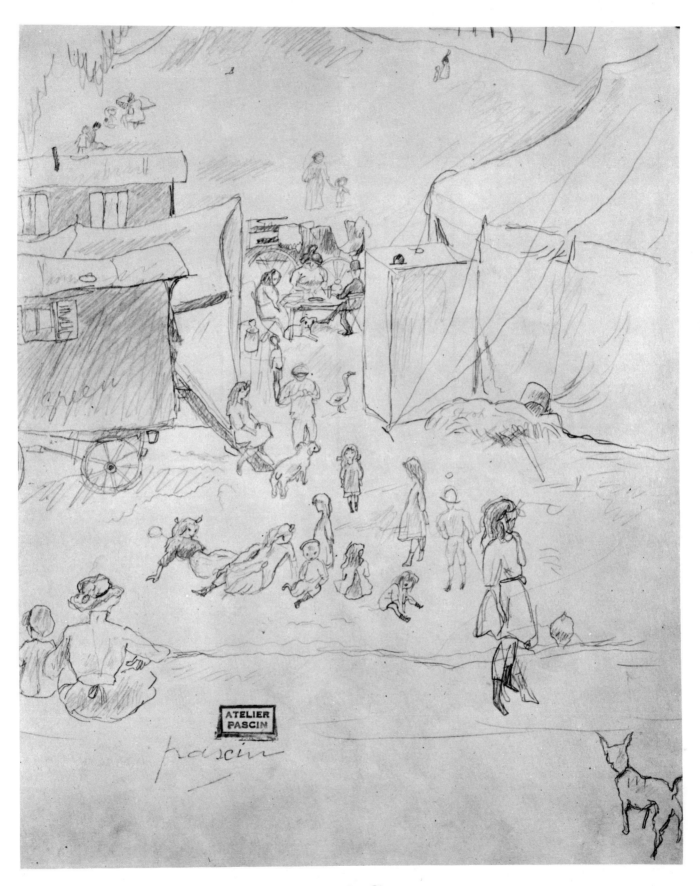

35. Setting Up the Circus; c. 1915

36. Three Women; c. 1915

37 . By the Sea; c. 1915

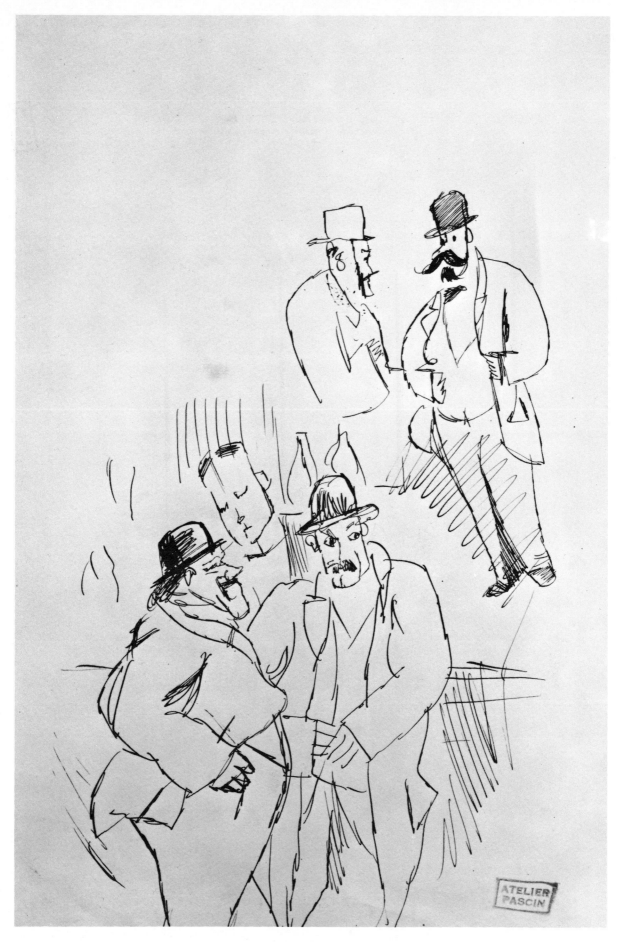

38. Study of Men; c. 1915

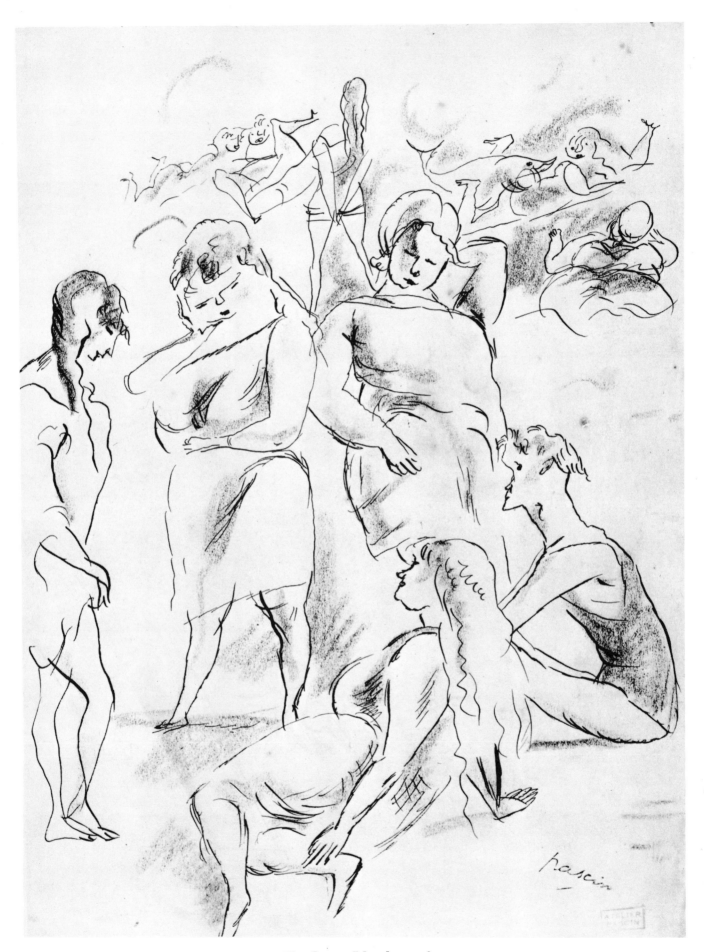

39. Coney Island; 1916

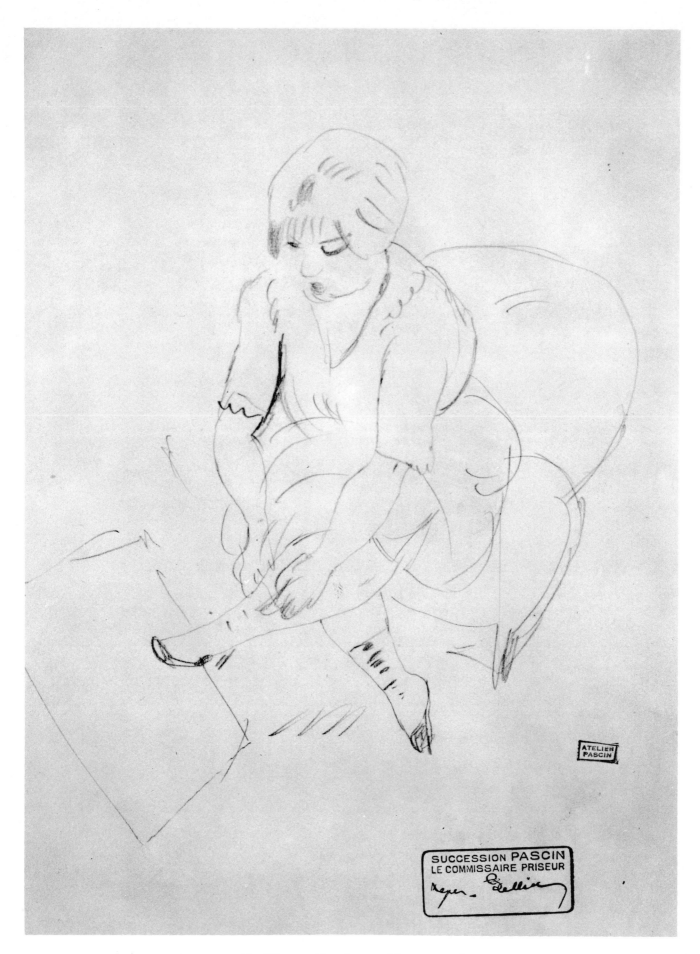

40. Woman Putting on Shoes; 1916

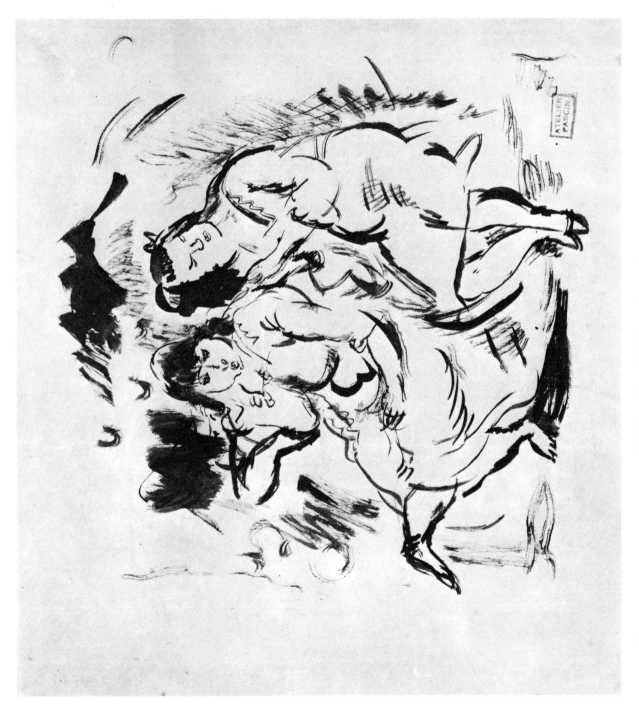

41. Two Seated Women; 1916

pascin

42. New Orleans; 1916

43. Pop Hart; c. 1916

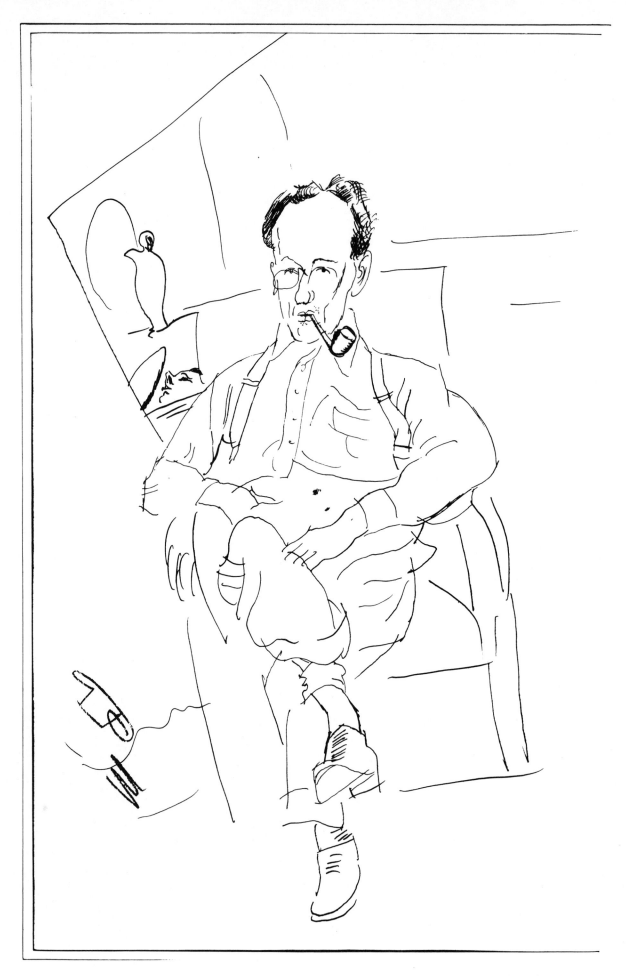

44. Portrait of Charles Laborde; c. 1916

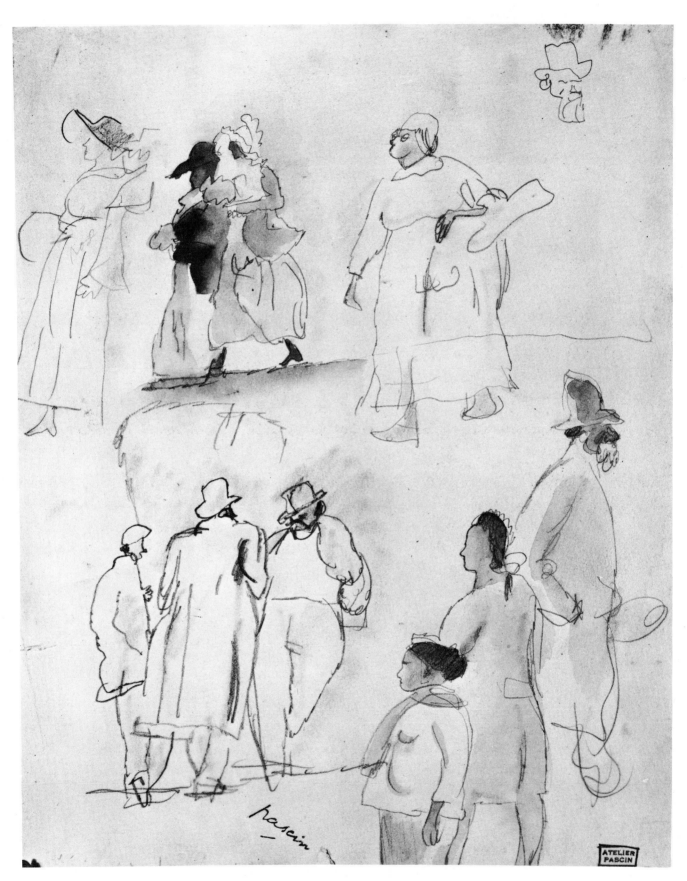

45. Sheet of Studies; 1917

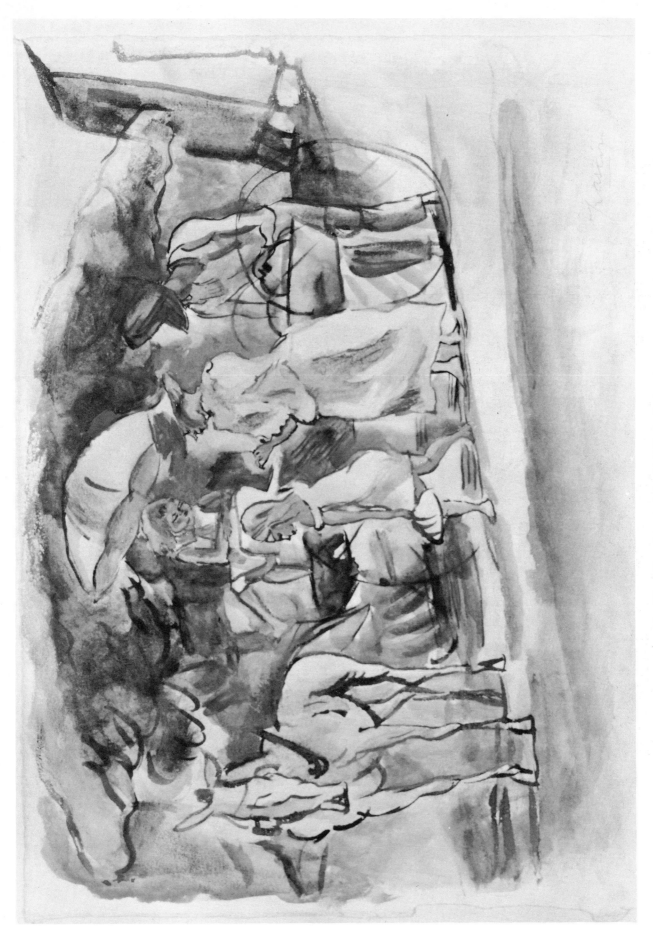

48. The Carriage with the Pink Parasol; c. 1917

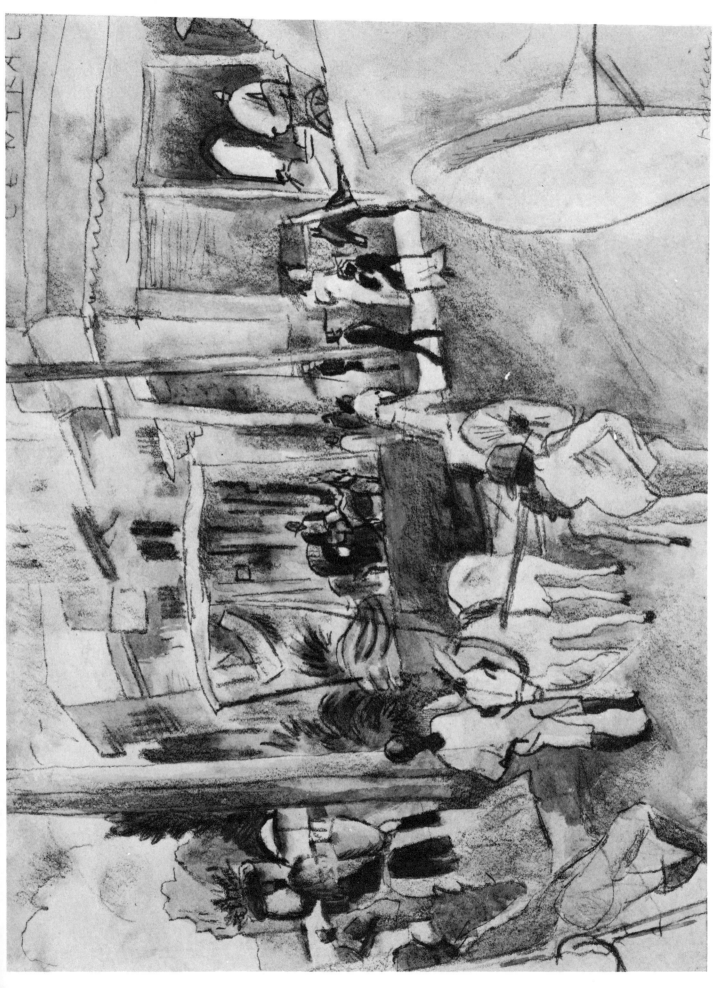

49. Scene in Havana; 1917

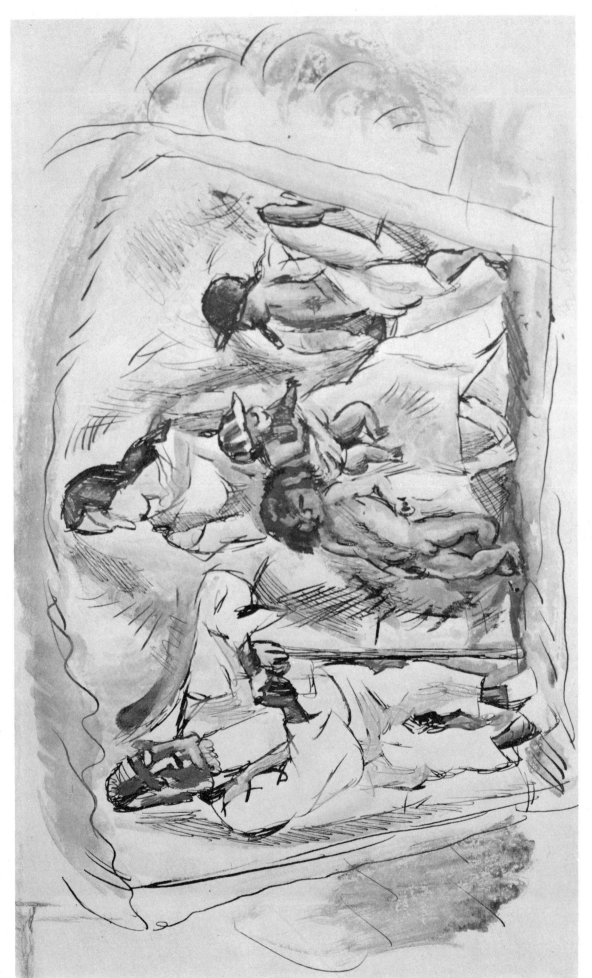

50. The Southern Family; c. 1917

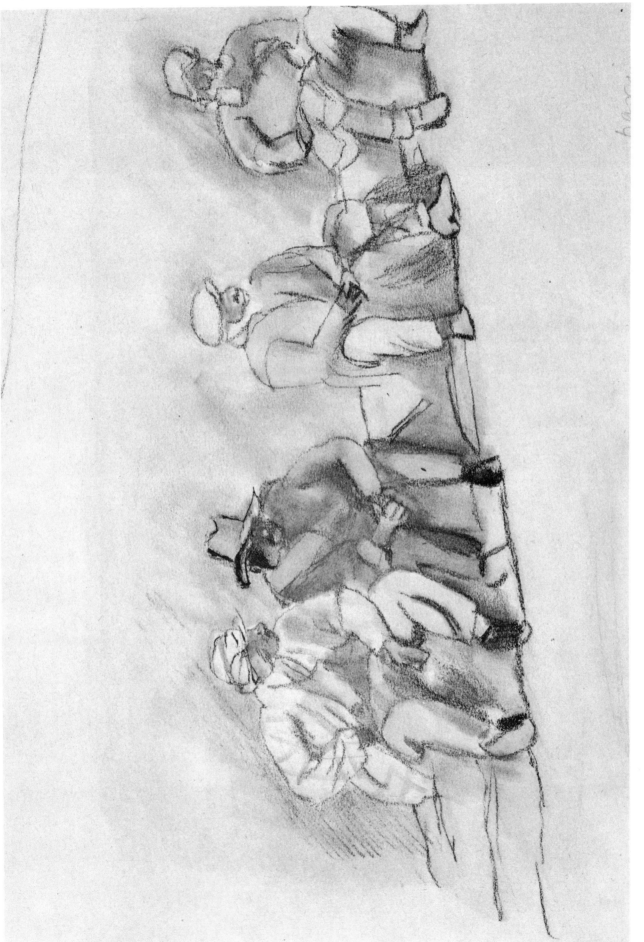

51. Seated Figures; 1917

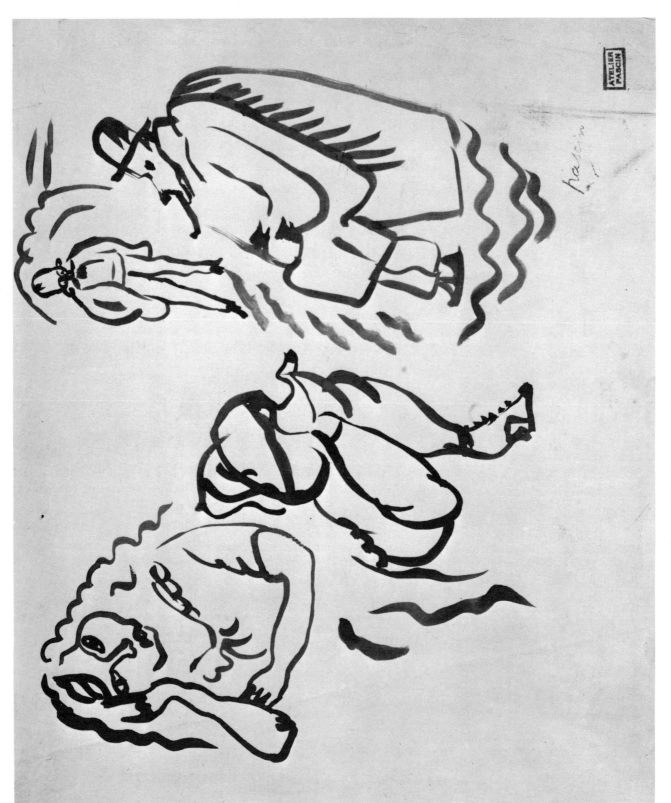

52. People in Havana; 1917

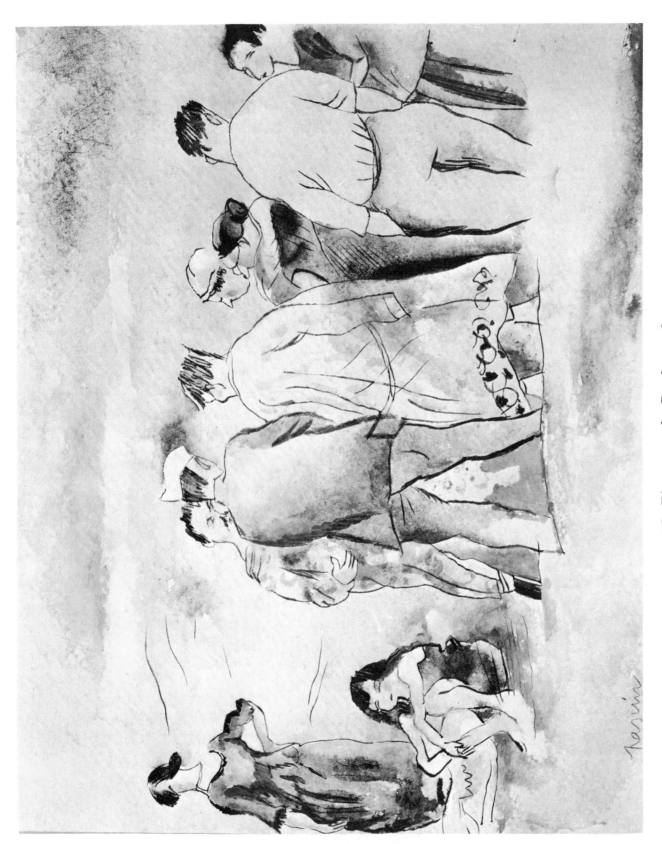

53. Dispute on the Beach; 1918

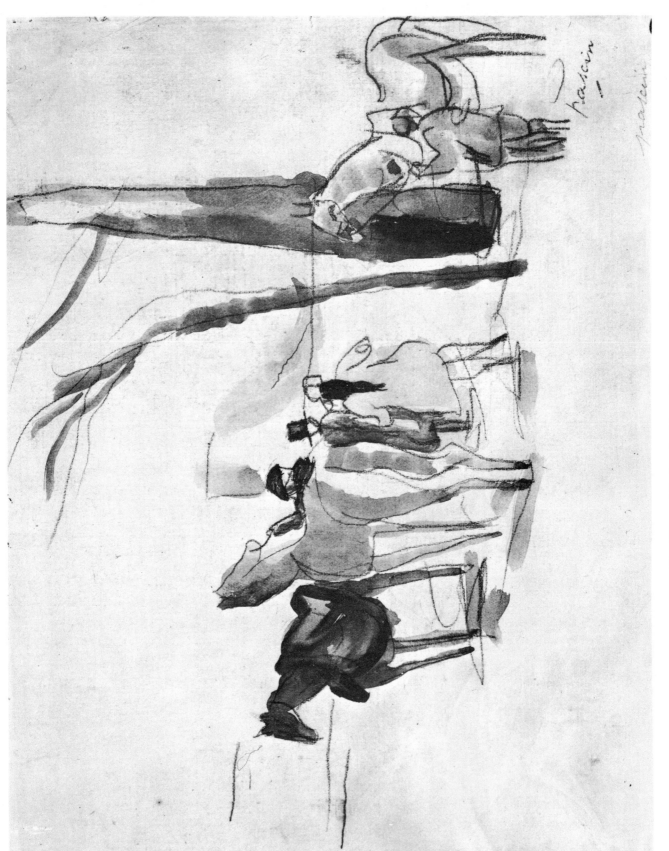

54. Horse Market in New Orleans; 1918

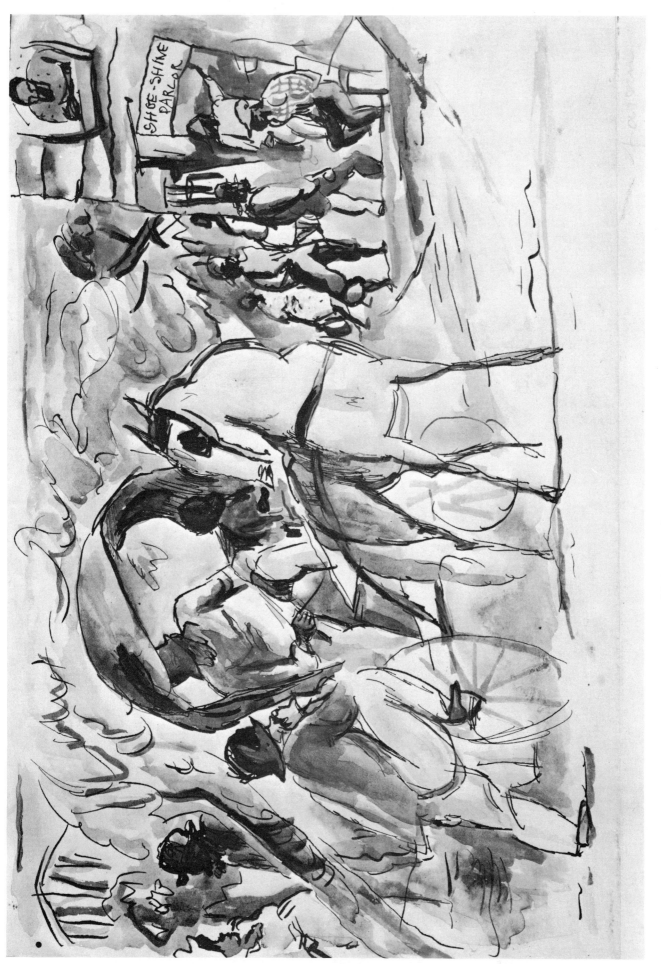

55. New Orleans Intermezzo; 1918

56. A Park in New Orleans; 1918

57. In New Orleans; 1918

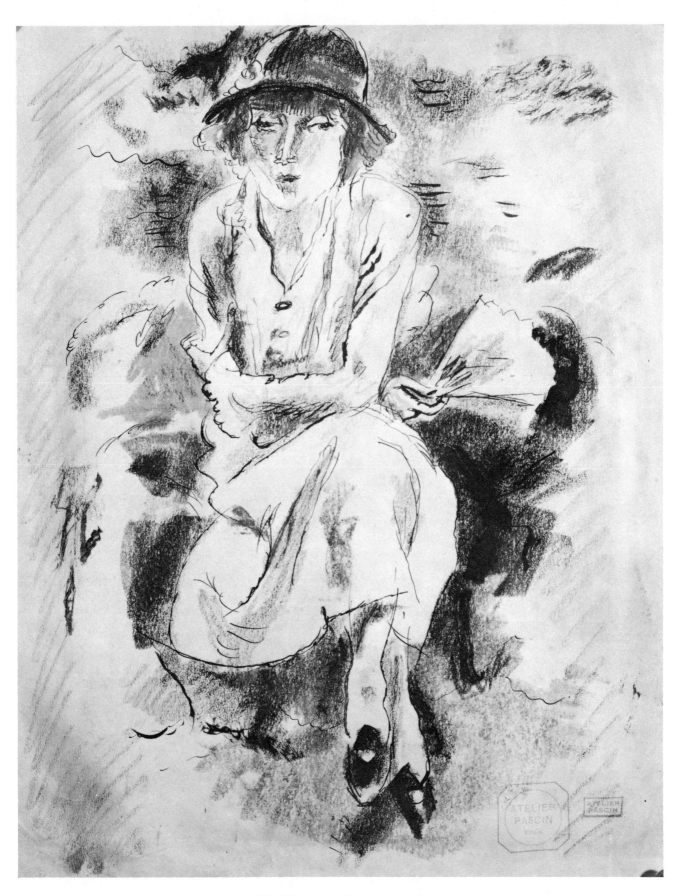

58. Hermine David; 1918

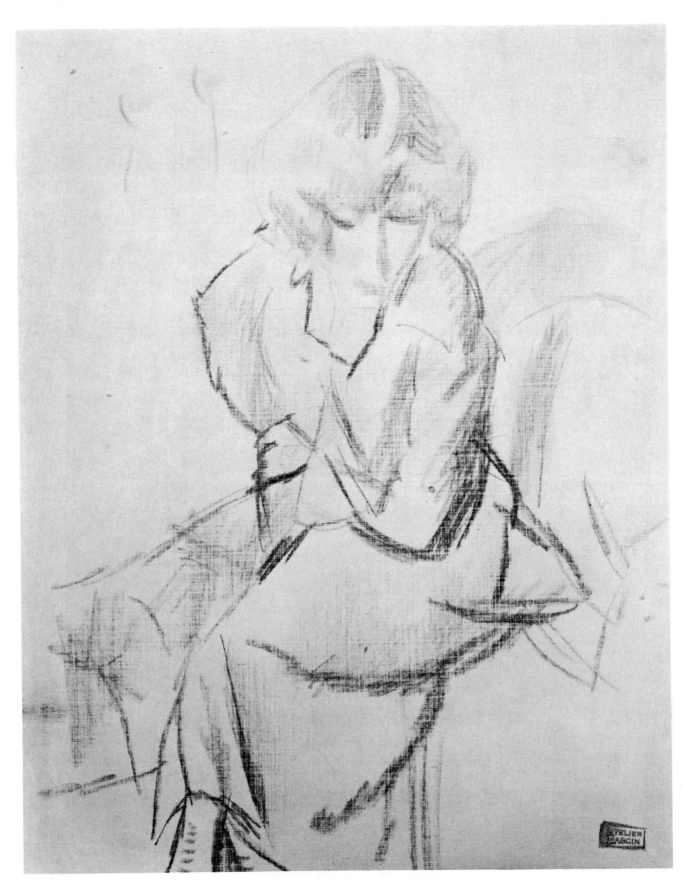

59. Hermine David; 1918

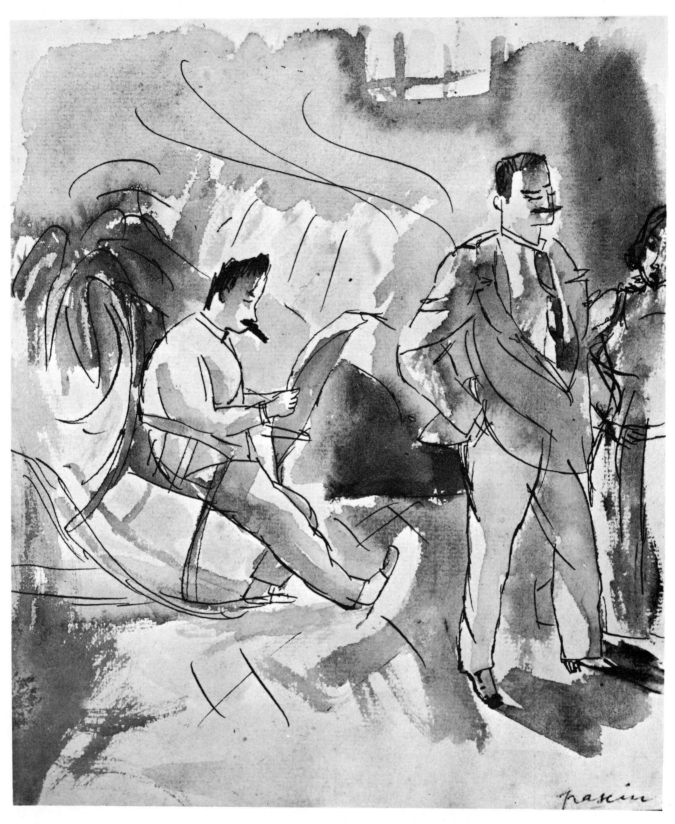

60. Man Reading; 1918

61. The Reception; c. 1918

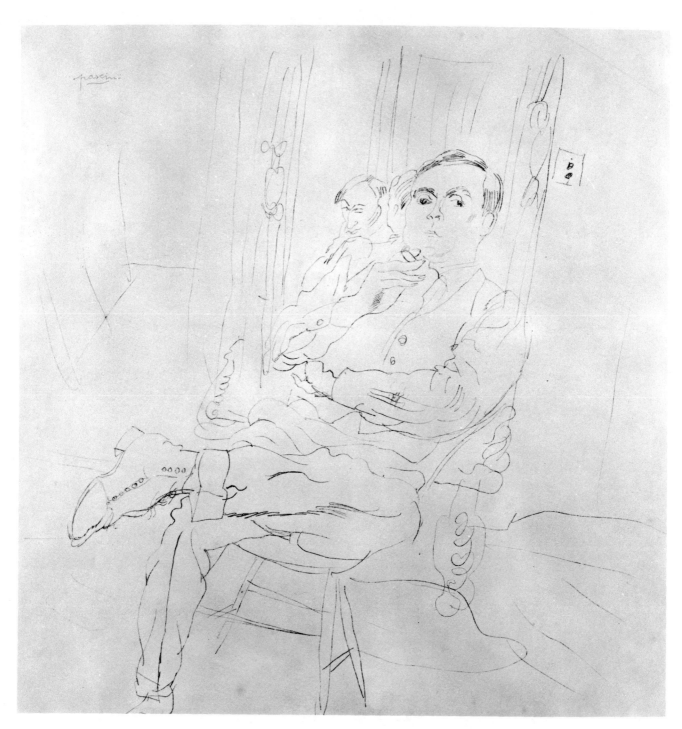

62. Portrait of the Artist and His Friend; c. 1918

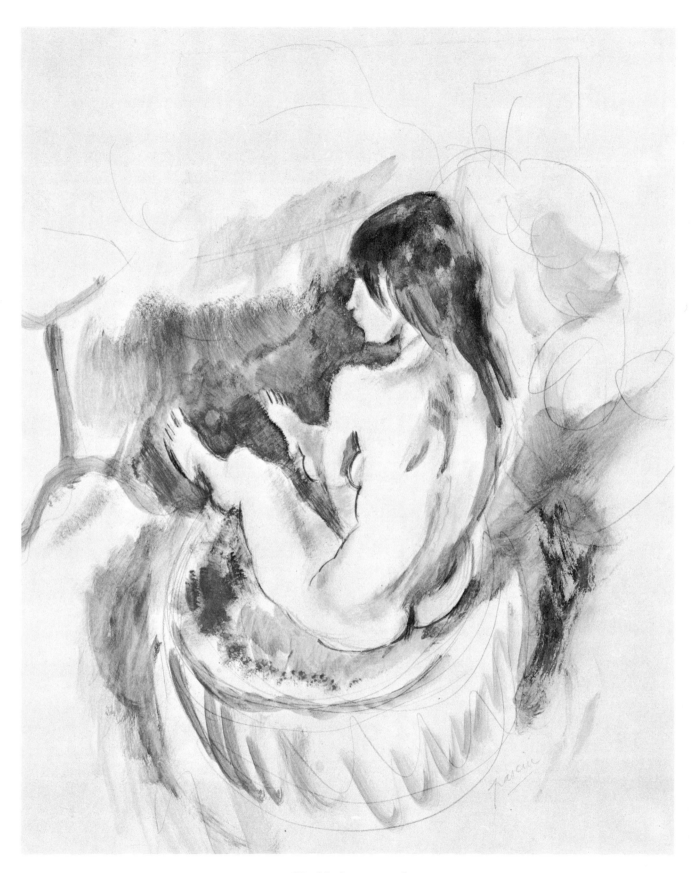

63. Nude; c. 1918

64. On the Ferry; 1919

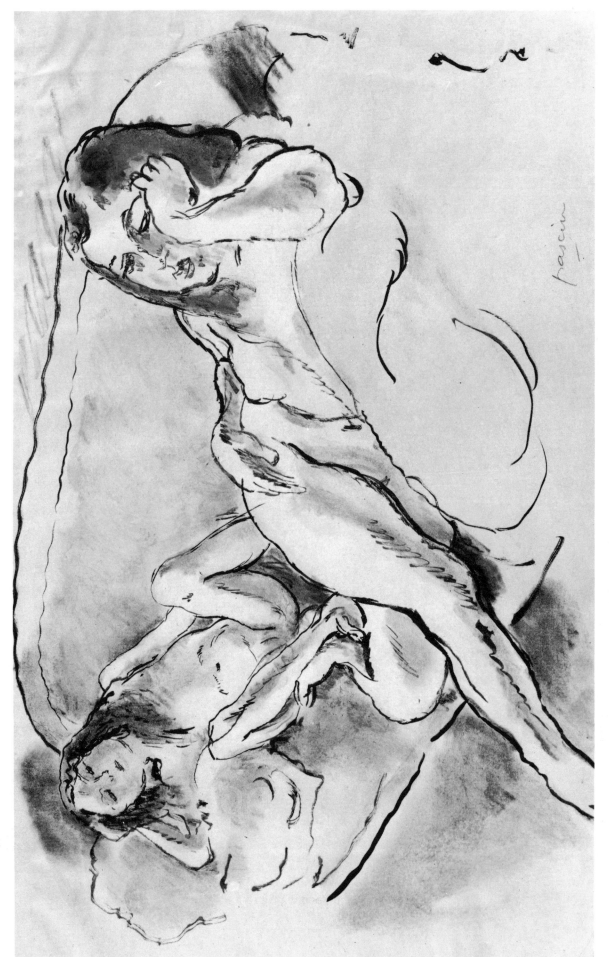

65. Two Prostitutes on a Sofa; 1919

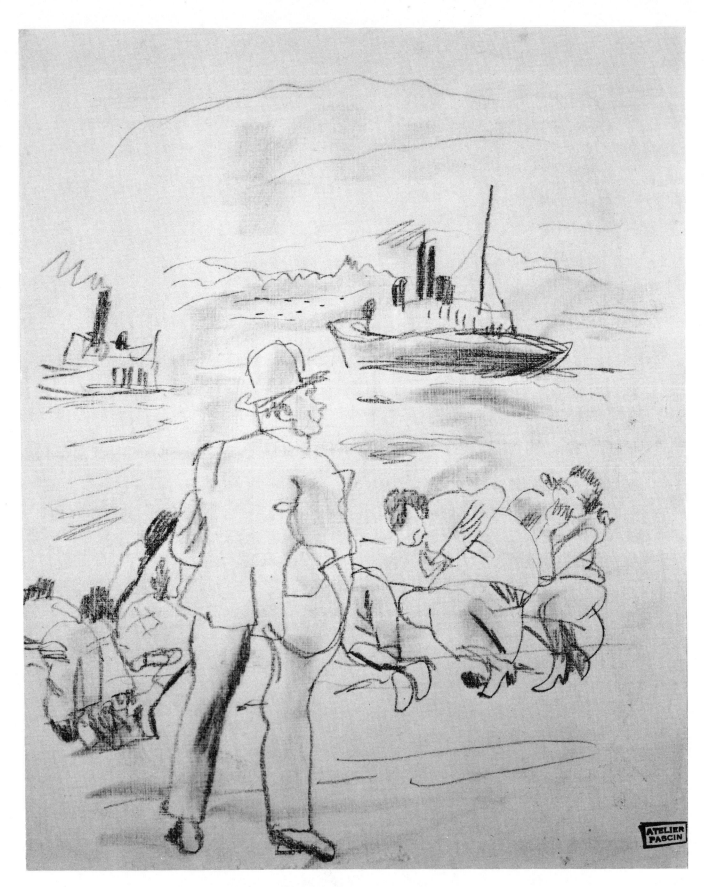

66. Harbor Scene; 1919

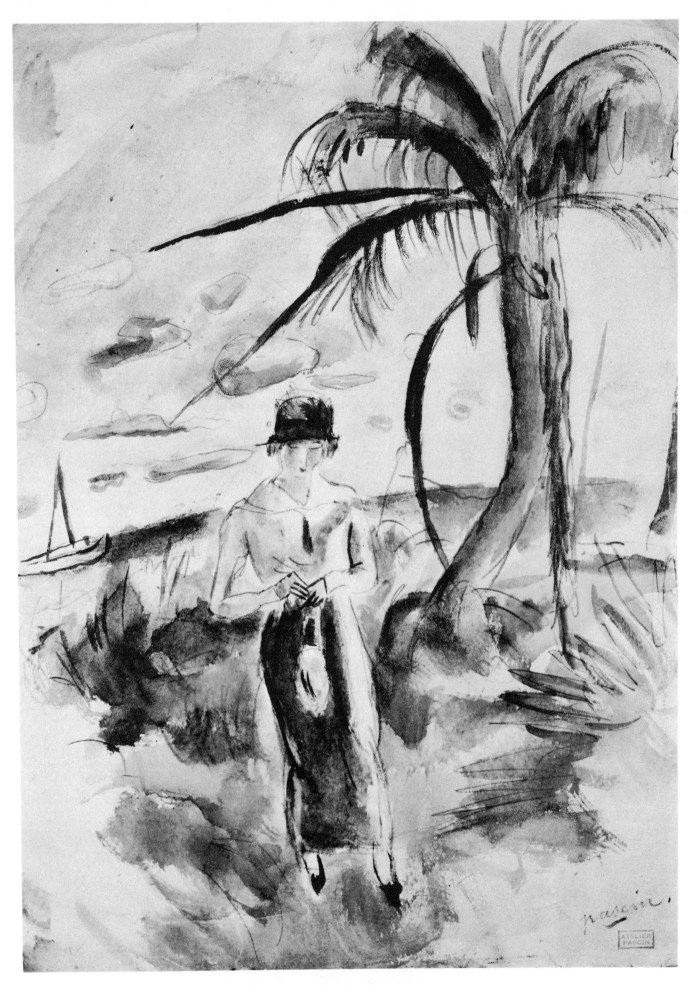

67. Hermine David in the Tropics; 1919

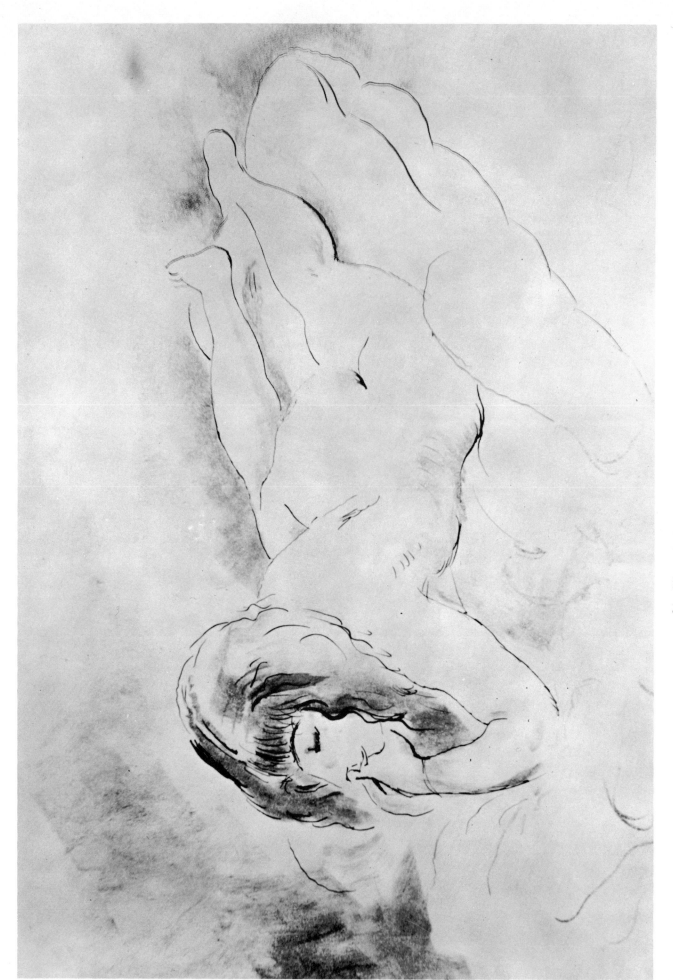

68. Hermine on Her Bed; c. 1920

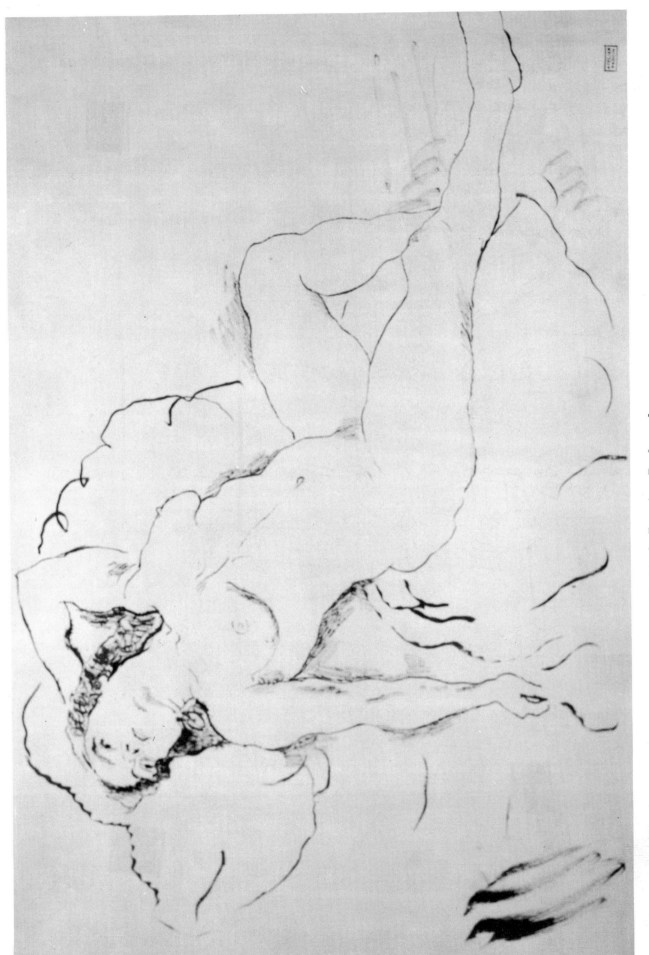

69. Nude Leaning Backward; 1920

pascin

70. In the Subway; 1920

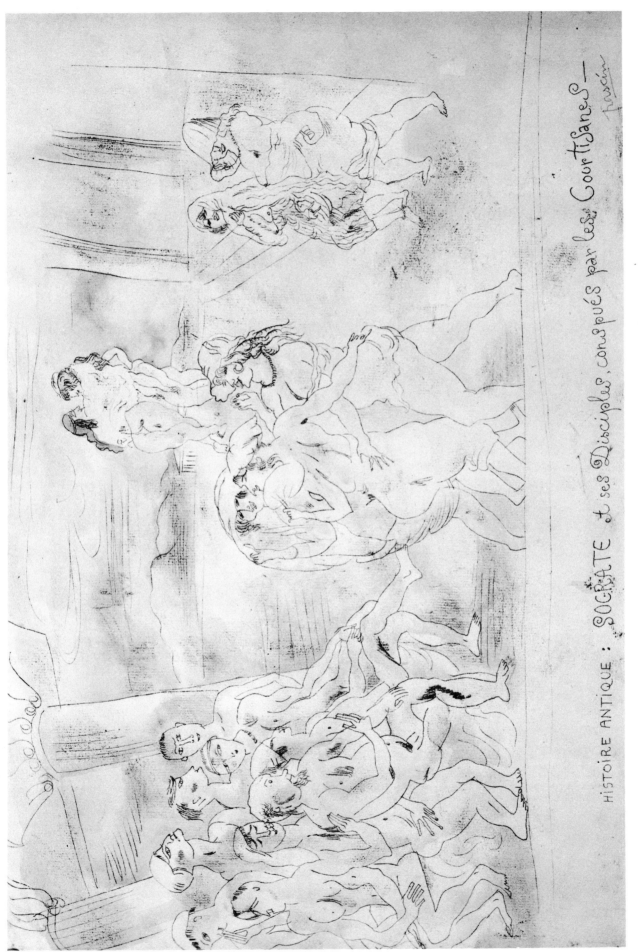

HISTOIRE ANTIQUE : SOCRATE et ses Disciples, conspués par les Courtisanes —

71. Ancient History: Socrates and His Disciples Reviled by the Courtesans; 1920

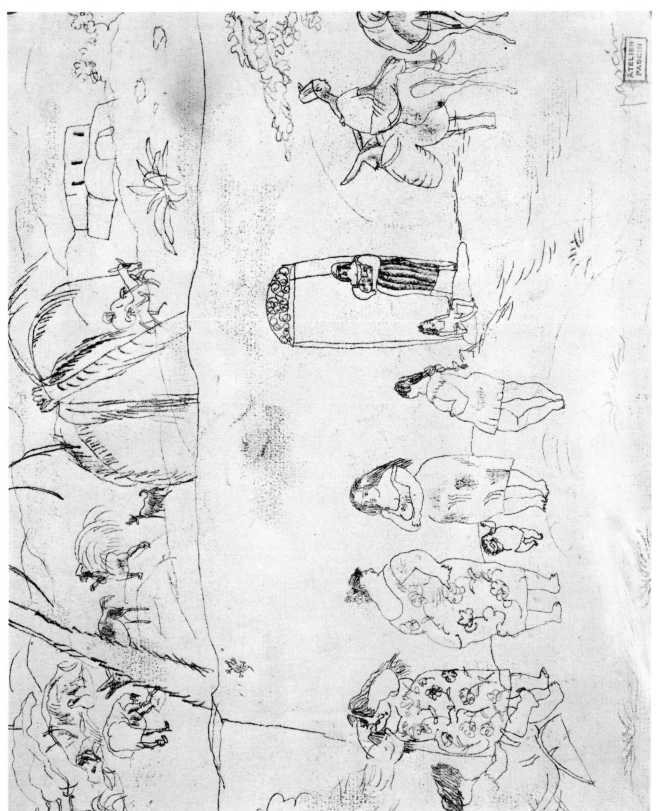

72. Landscape in Tunis; 1921

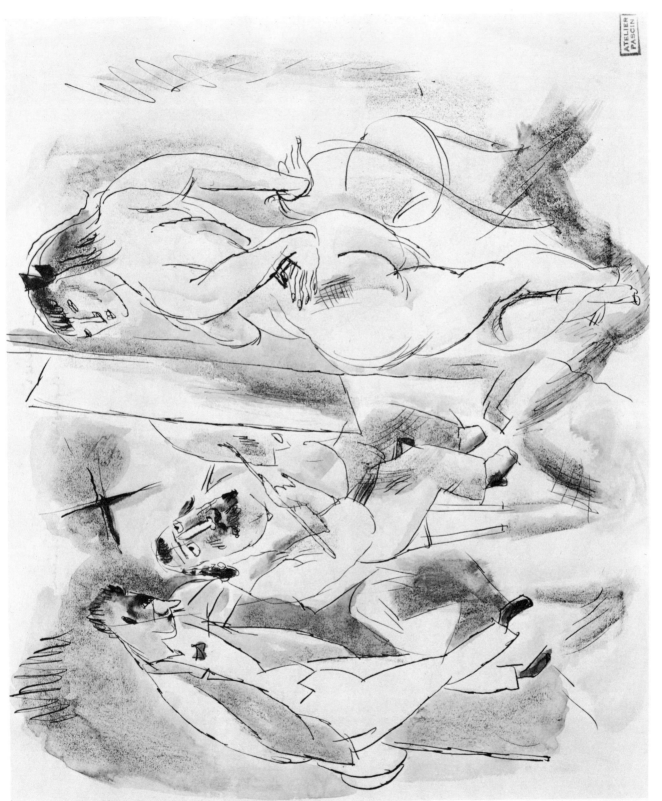

73. An Artist's Studio; 1921

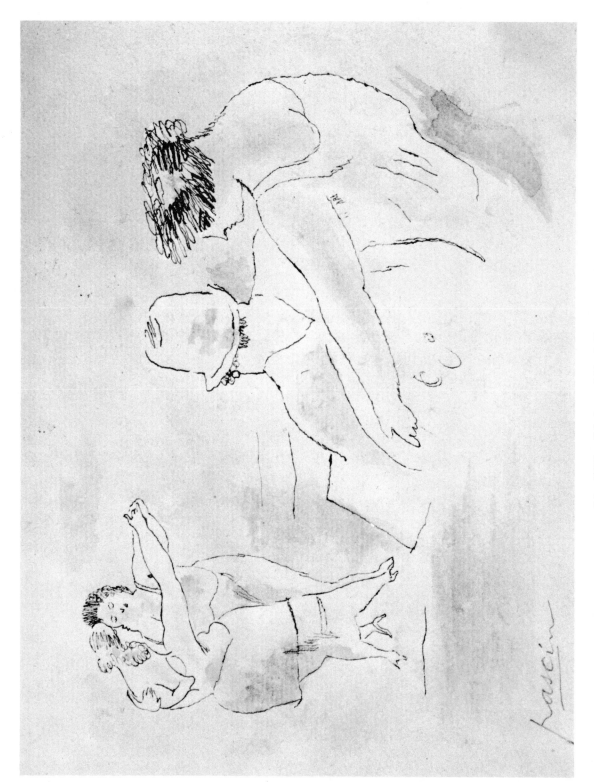

74. "The Lights of Paris"; 1921

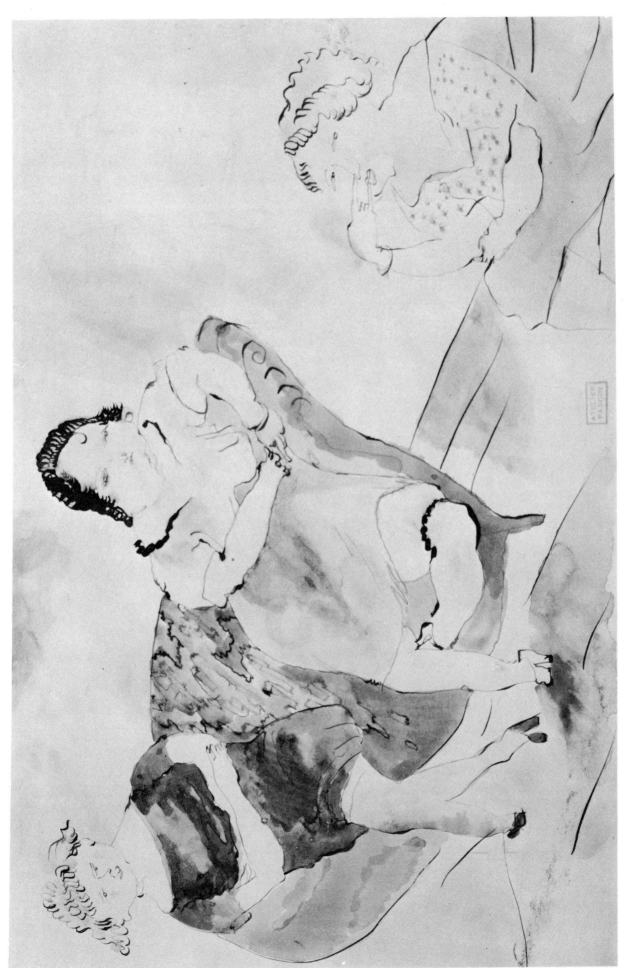

75. Three Prostitutes; c. 1921

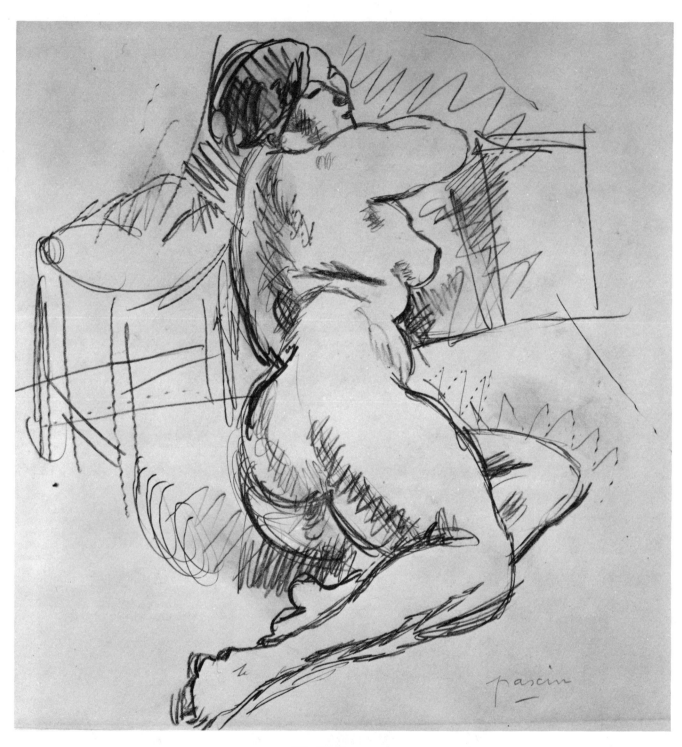

76. Nude; 1922

77. Drawing Lesson; 1922

80. In the Café; 1925

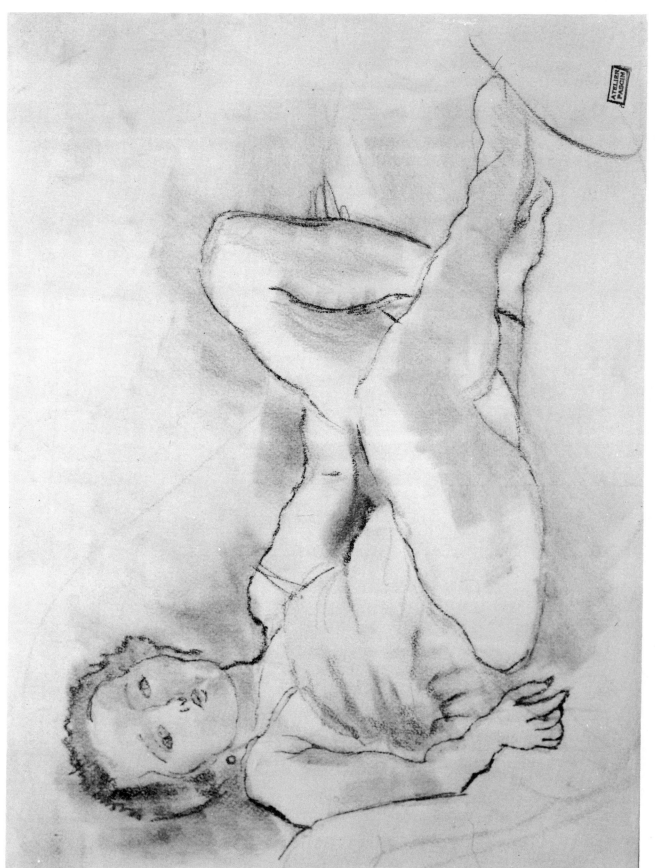

81. Resting on a Chaise Longue; 1925

82. Homage to Berthe Weill; 1925

83. The Visitors; c. 1925

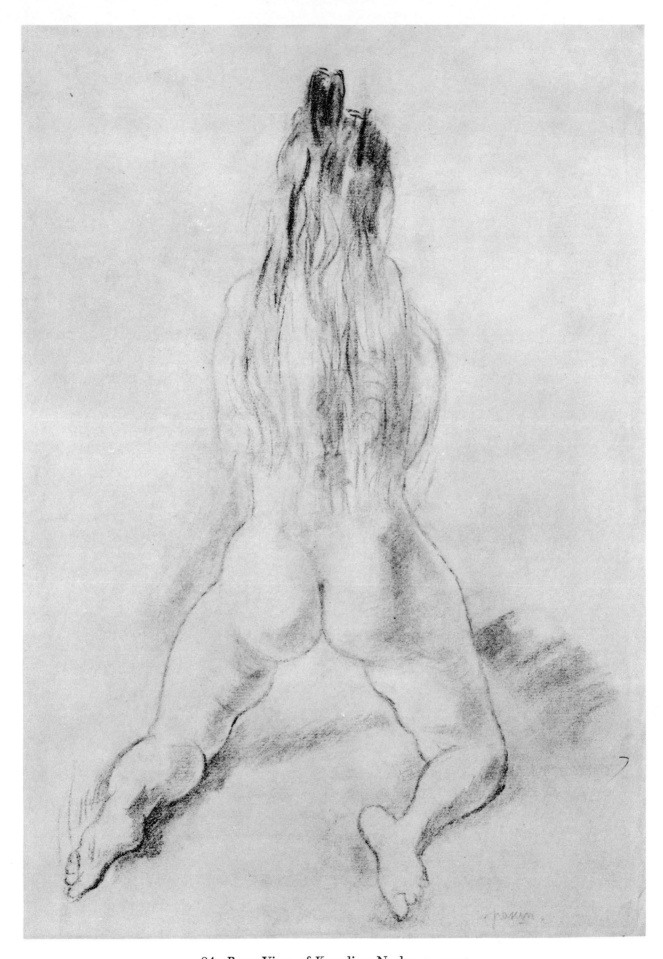

84. Rear View of Kneeling Nude; c. 1925

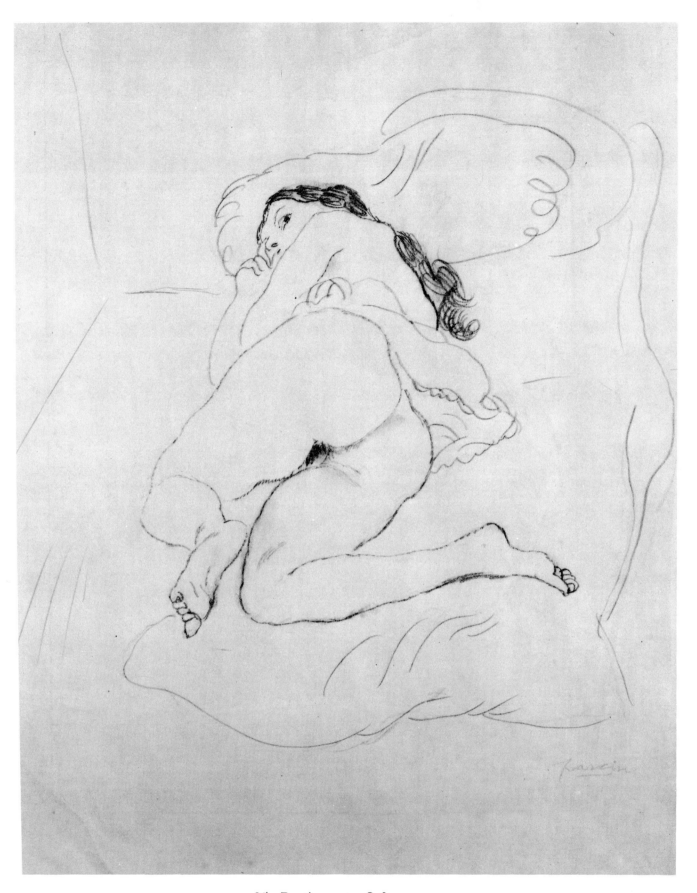

85. Resting on a Sofa; c. 1925

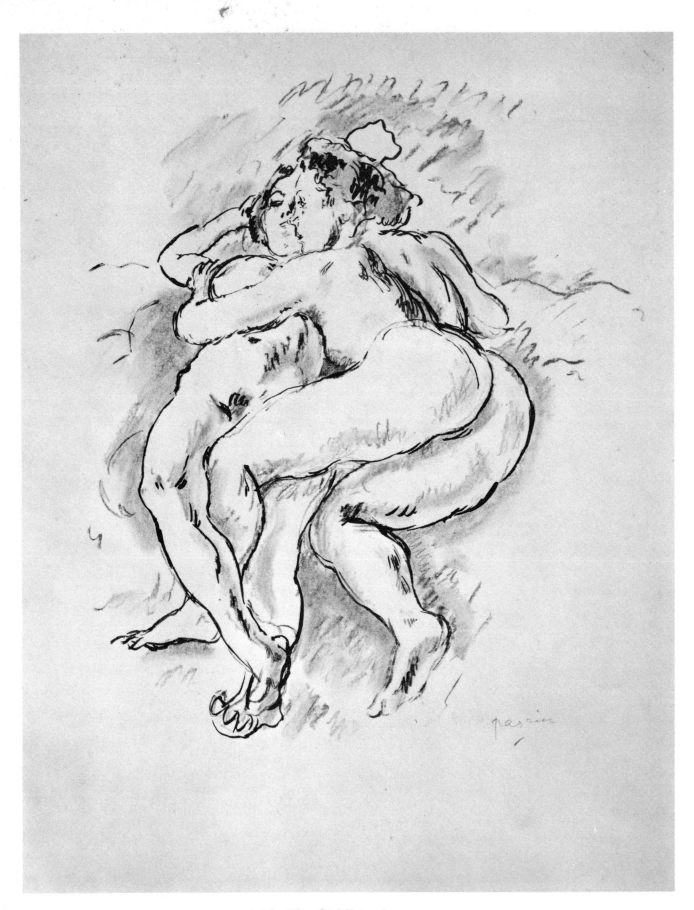

86. The Girl Friends; 1925

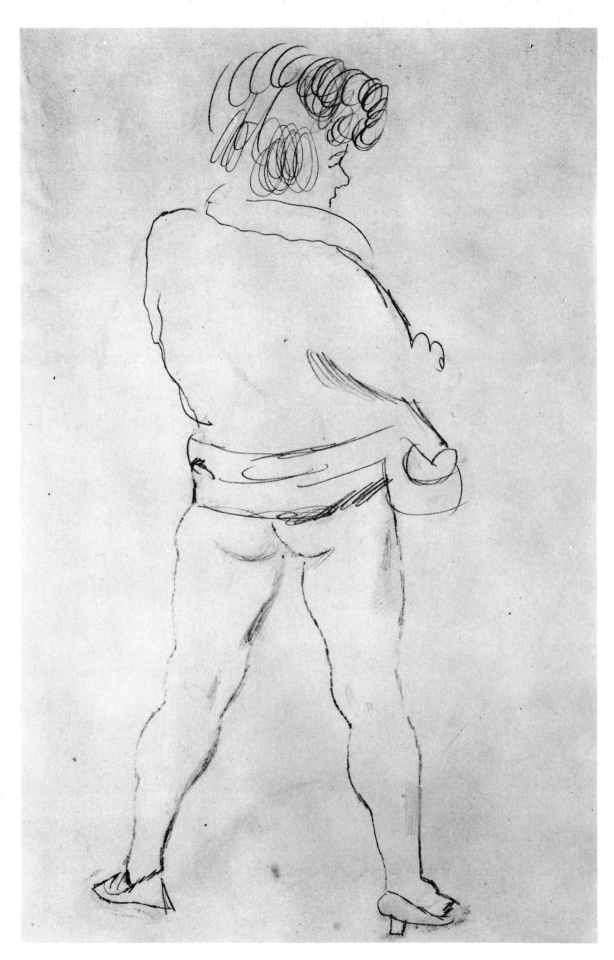

87. Rear View of Standing Seminude Woman; 1926

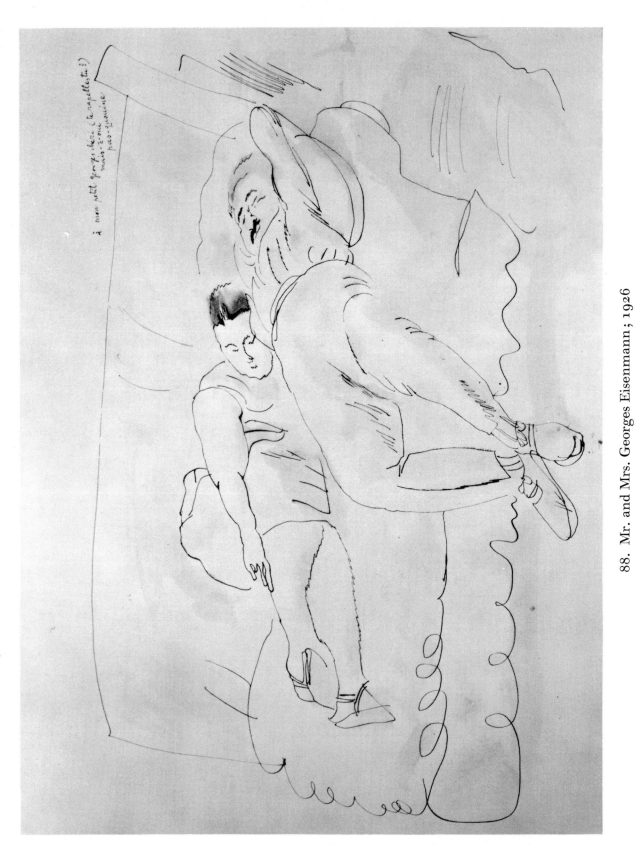

88. Mr. and Mrs. Georges Eisenmann; 1926

Inscription: "To my dear little Georges (do you remember?)—Sure I do, Pasquin."

à mon ami Georges Eisenmann
MATA-HARI-PASCIN
11 mai 1926

89. Georges Eisenmann; 1926

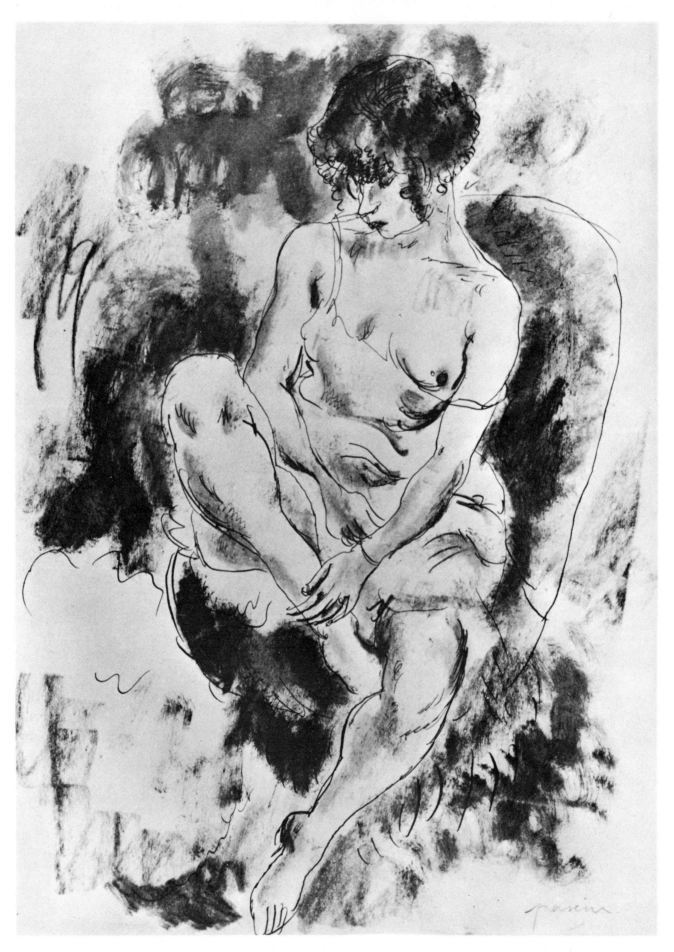

90. Redhead in a Blue Slip; 1926

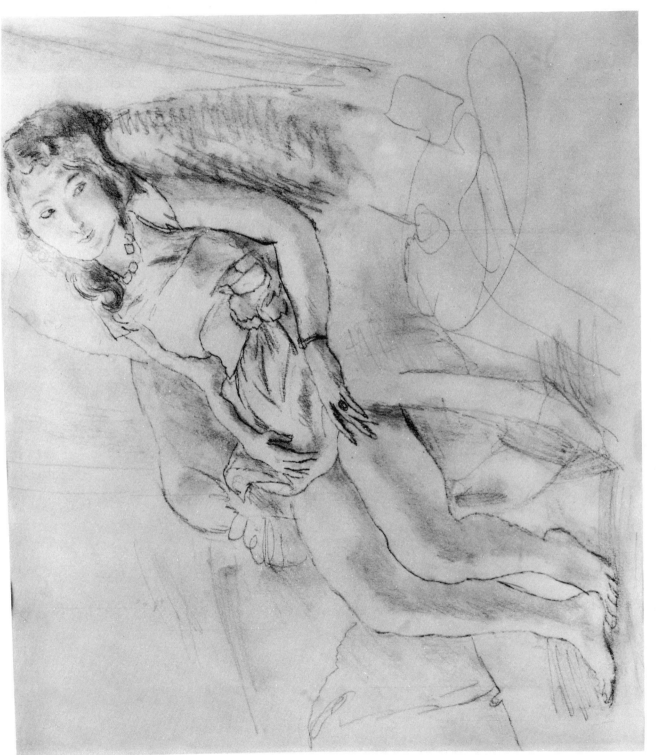

91. Girl in an Armchair; c. 1926

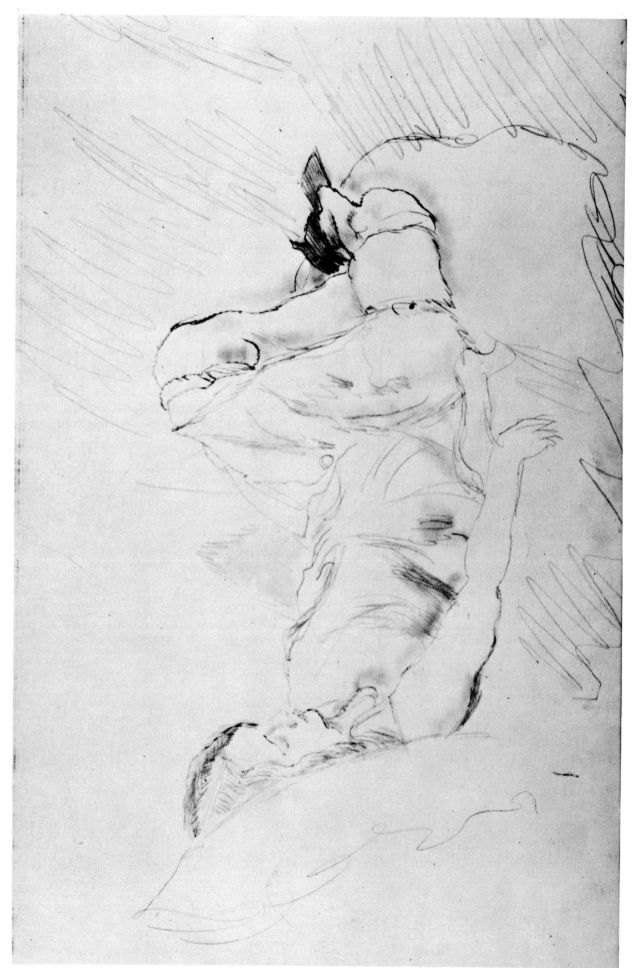

92. Reclining Girl; c. 1926

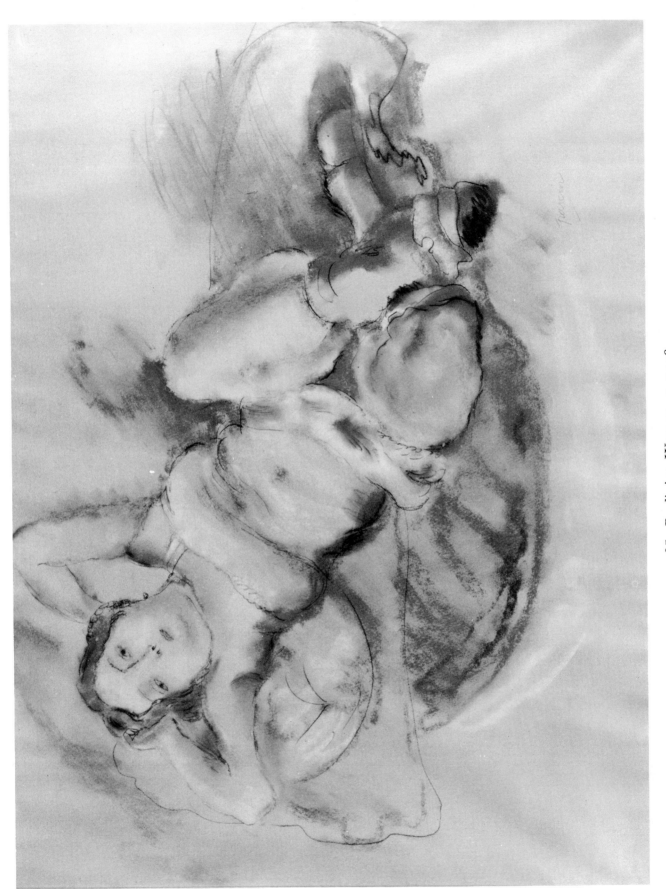

93. Reclining Woman; c. 1926

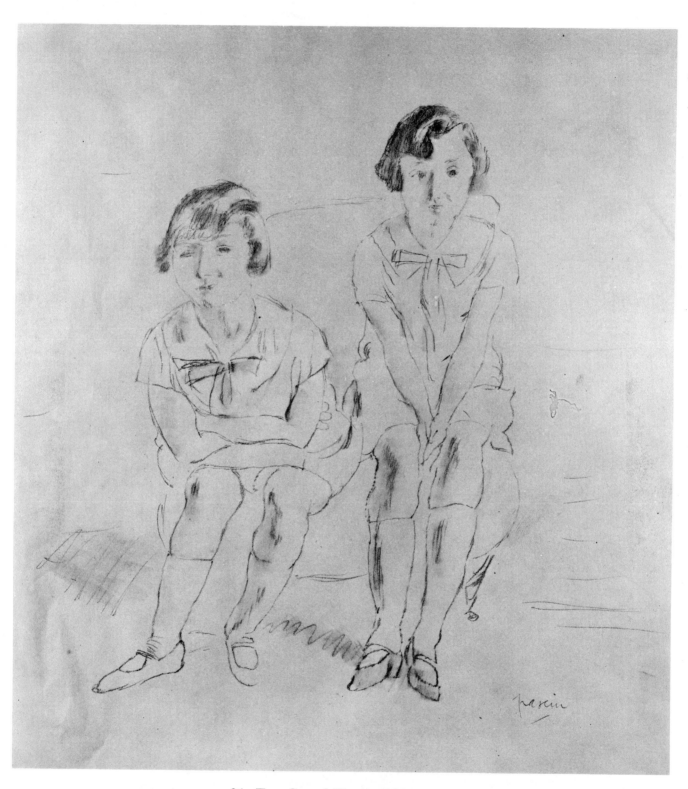

94. Two Seated Young Girls; 1927

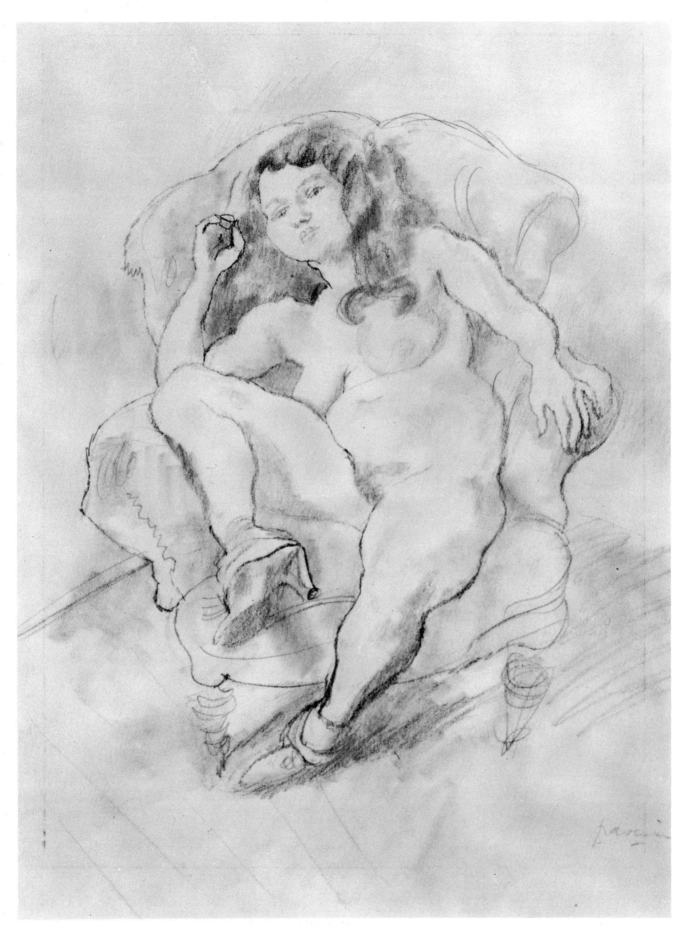

95. Nude in an Armchair; 1927

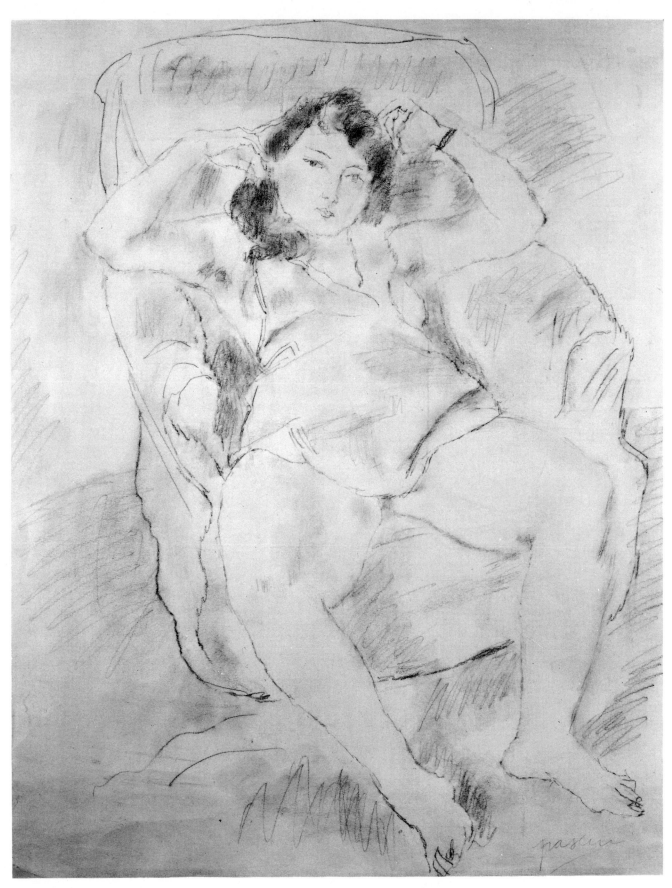

96. Girl in an Armchair; c. 1927

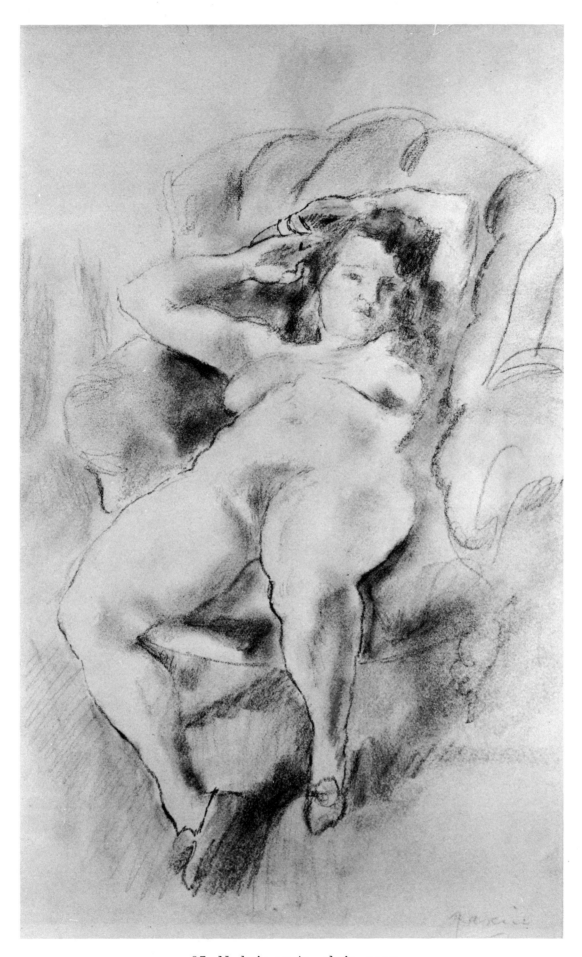

97. Nude in an Armchair; 1927

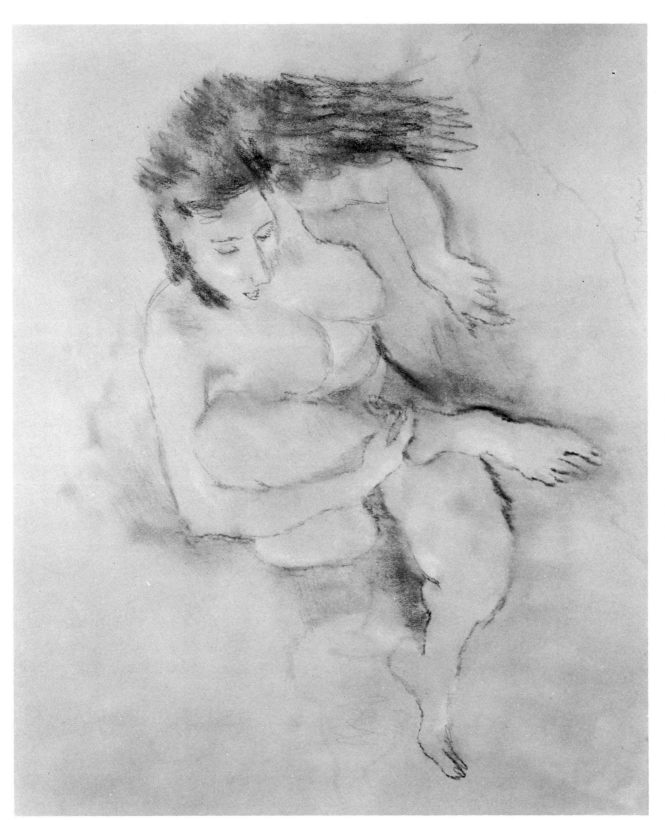

98. Nude with Hair Undone; c. 1927

99. Women with Children; 1928

100. Seated Girl; 1928

101. Reclining Nude; 1928

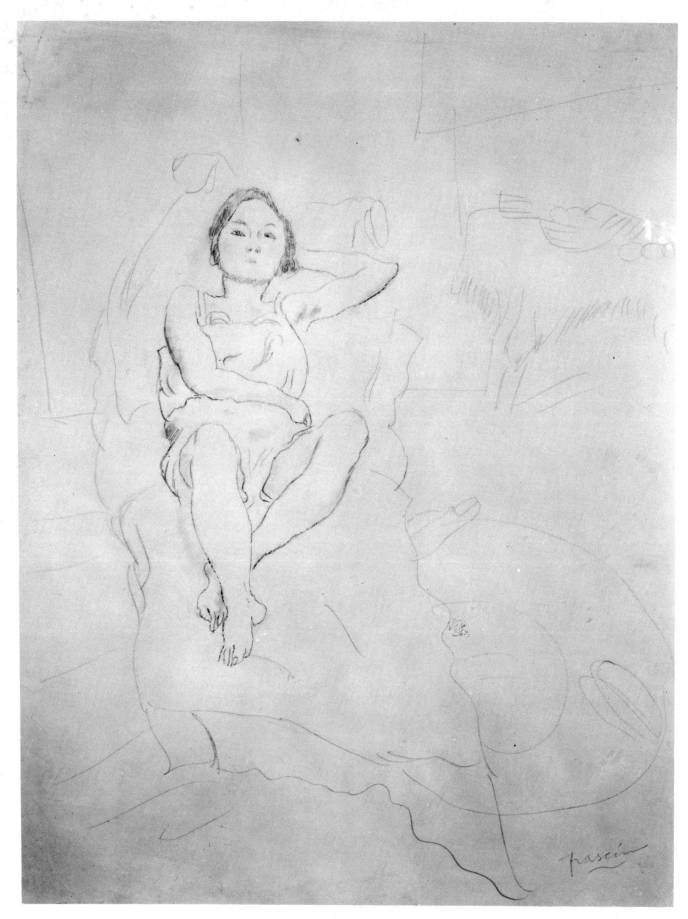

102. Model Resting; 1928

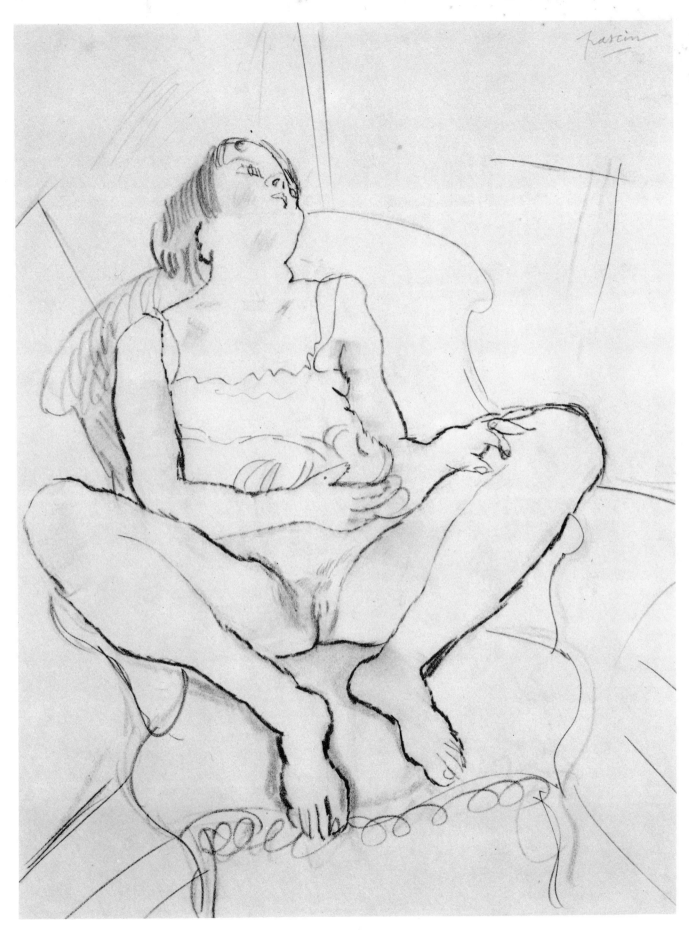

103. Girl in an Armchair; 1928

104. At the Cabaret; 1928

105. Bal Tabarin; c. 1928

106. Boston Streetcar; c. 1928

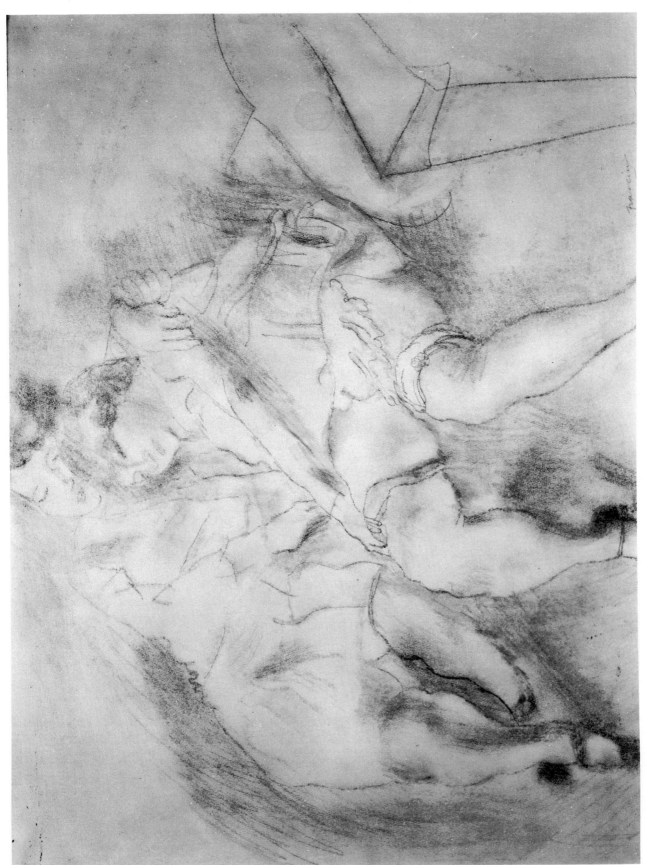

107. The Two Girl Friends; 1929

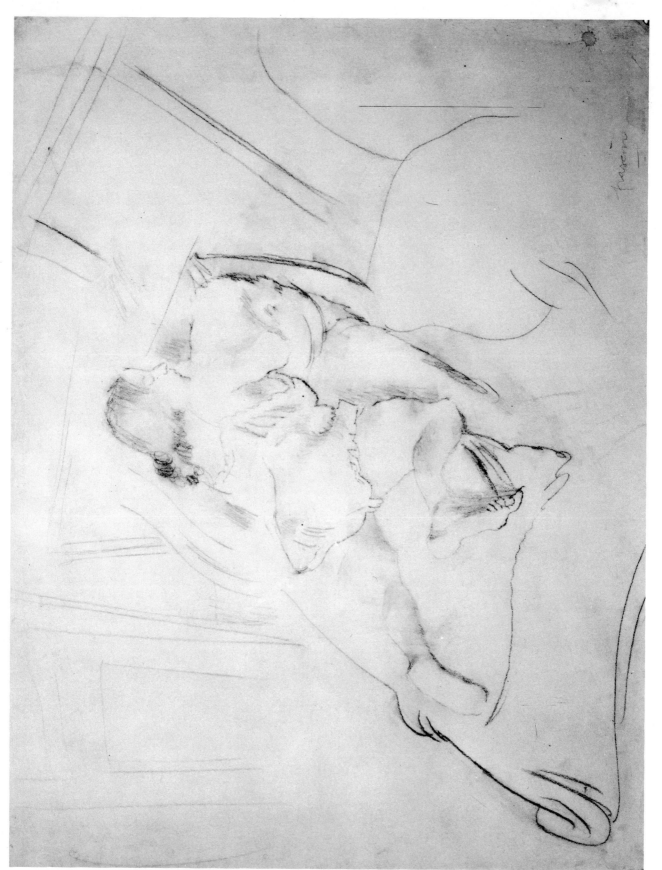

108. Girl on Her Bed; 1929

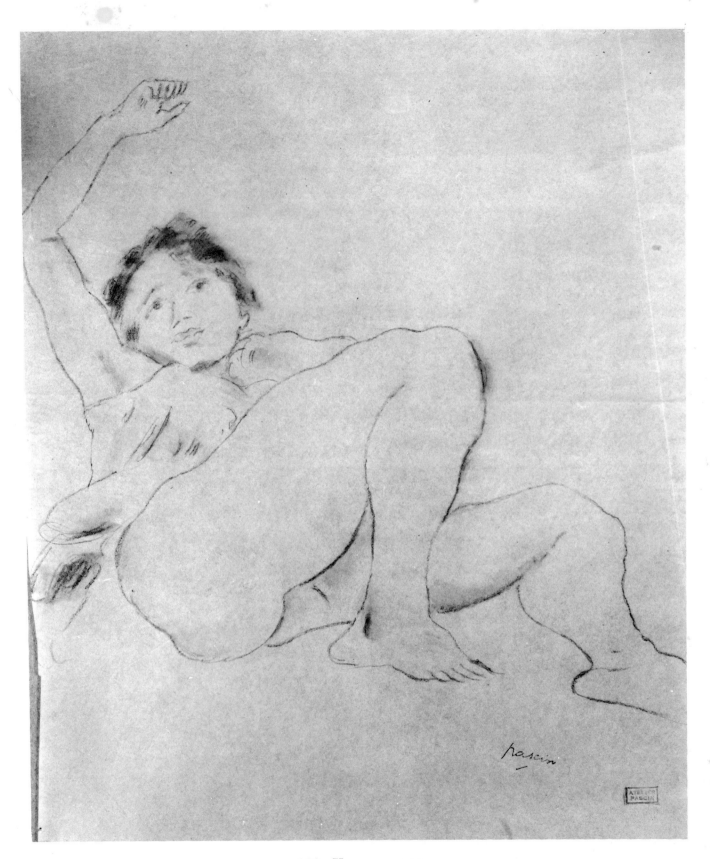

109. Yvonne; 1929